IRELAND EVER

IRELAND EVER

THE PHOTOGRAPHS OF JILL FREEDMAN

TEXTS BY FRANK McCOURT & MALACHY McCOURT

HARRY N. ABRAMS, INC., PUBLISHERS

EDITOR: Christopher Sweet

EDITORIAL ASSISTANT: Sigi Nacson

DESIGNER: Michael J Walsh Jr

PRODUCTION MANAGER: Jane Searle

Library of Congress Cataloging-in-Publication Data

Freedman, Jill.
 Ireland ever / photographs by Jill Freedman ; texts by Frank McCourt
and Malachy McCourt.
 p. cm.
Includes bibliographical references and index.
 ISBN 0-8109-4340-9 (hardcover)
 1. Ireland—Pictorial works. 2. Ireland—Description and travel. I.
McCourt, Frank. II. McCourt, Malachy, 1931- III. Title.

 DA982.F735 2003
 941.70824′022′2—dc22

 2003020355

Published in 2004 by Harry N. Abrams, Incorporated, New York.

Printed and bound in Singapore.
10 9 8 7 6 5 4 3 2 1

Harry N. Abrams, Inc.
100 Fifth Avenue
New York, N.Y. 10011
www.abramsbooks.com

Abrams is a subsidiary of LA MARTINIÈRE

*To purchase original prints, copies of her rare
and out-of-print books, or to otherwise contact
the photographer, please go to Jill Freedman's
website:* **www.jillfreedman.com**

half-title page: **FINUGE** County Kerry

frontispiece: **CONNEMARA** County Galway

opposite: **BALLYBUNION** County Kerry

below: **PUCK AND CASTLE** County Clare

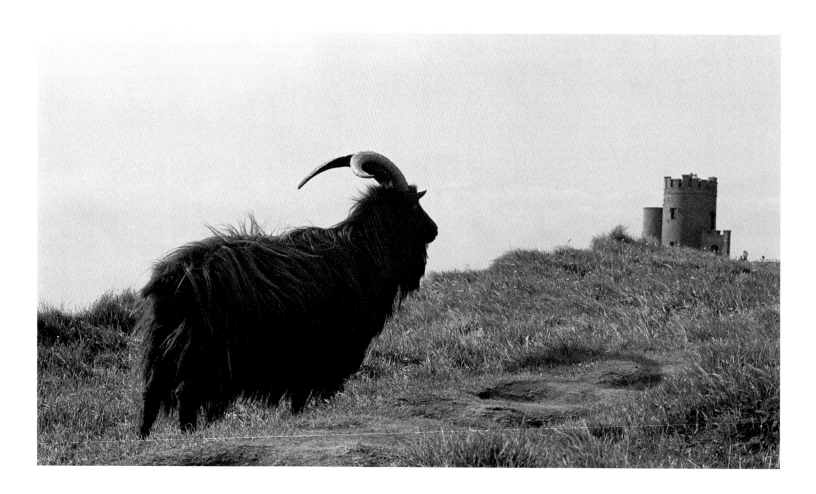

Acknowledgments

CHRISTOPHER SWEET is my editor, and how sweet it is, working with a man
who not only knows a good idea when he sees one, but who stands behind it all the way.
MICHAEL WALSH, the great designer, took my pictures and turned them into a book.
They gave it the best production possible. It was a joy working with two such consummate
professionals; I loved every minute. ¶ Thanks to my old friends FRANK and MALACHY
MCCOURT, who have been a source of encouragement and laughs for many years.
Same goes for Beverly Rubin Morris, Jack Deacy, Maggie Steber, and Sue Davies.
The Irish Consulate in New York made me an Honorary Irishwoman in 1987.

This is in memory of my dear friend Angela Moloney, who made me a Kerry woman.

Jill Freedman's Ireland Ever

Show me where you point your camera and I'll tell you what you are. ¶ Well, it's a bit of a glib statement but there's a nugget of truth in it. Take your time turning the leaves of Jill Freedman's *Ireland Ever* and you'll discover something about the artist herself. You'll see how she rejoices in people, animals, music. There is a picture of two boys on one side of a wall and some priests on the other side. The priests are solemn as befits the men who once ruled Ireland with iron hand. What are those boys laughing about? You can speculate and if you do you'll be speculating in the right direction—especially when you know how the church has weakened in Ireland. ¶ Jill offers us an occasional landscape. If it isn't a study in cloud, mist, and tilled field it is peopled (if that's the right word) with animals. There's a cow in the County Kerry just grazing away. You could have taken that picture, couldn't you? Just a cow in a field. Here is a scene of a sheepdog watching his flock. It is delicious, the kind of picture that makes you want to run out and buy a camera. ¶ And that's because you think you could do it. Right? All you have to do is point your camera. ¶ But wait. This is a book awash in beauty and hands. Yes, hands. This is a book about the rural Irish at work and at play and, sometimes, doing nothing. But, it seems, their hands are always busy. They caress children, animals, and the noble pint. ¶ All through the book there are hands holding pints. Look at this man in Drumkeeran, County Leitrim (page 37). His right hand holds a pint, barely touched. His left arm rests on a table which sports four empty pint glasses, a pack of cigarettes, a plate with crumbs. Did ever man look so happy? That full pint glass. So much to look forward to. ¶ Back to the hands. There's a picture in the book that shows a man in a pub feeding his pony a pint (page 36). Did you ever see the likes? Then there is the pub scene in Finuge, County Kerry (page 144). Man is draining his pint glass while his son yawns and waits; the son, by the looks of it, having finished several glasses of lemonade—or something. ¶ Hands hold pints, hands hold cigarettes, hands play flutes, fiddles, accordions, bodhrans, tin whistles, uileann pipes. There's no end to the music in this gorgeous book, no end to the deep joy in life. ¶ I have a favorite picture. The setting is Tawnylea, County Leitrim. A muscular, curly-haired man is holding a child who is reaching up to touch his face. It is a scene of pure delight, love enshrined forever, and it tells you something about the photographer and where she points her camera. ¶ There is lamentation nowadays that the old Ireland is disappearing, the Ireland that was among the poorest of nations. No, it won't disappear. Look at these pictures and discover joy. There will always be a song and a story and the great laugh that follows. There will always be a man and a child and a dog with his sheep. There will always be mischievous boys and priests wondering what's going on here. ¶ And there will always be Jill Freedman pointing that camera and reminding us of what is true and beautiful. **—Frank McCourt**

TAWNYLEA County Leitrim

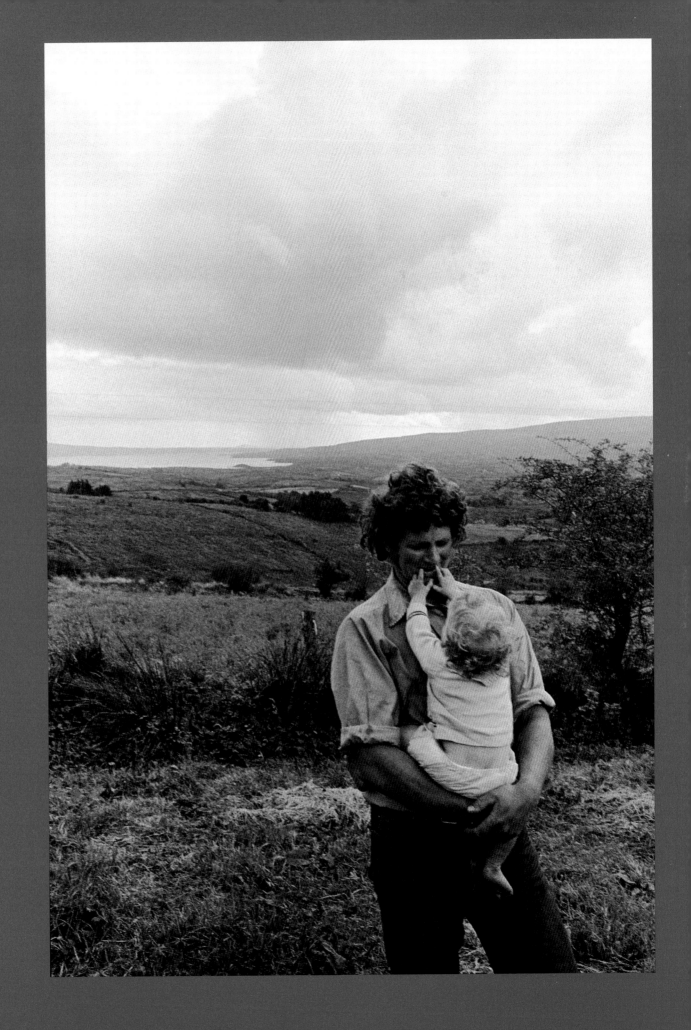

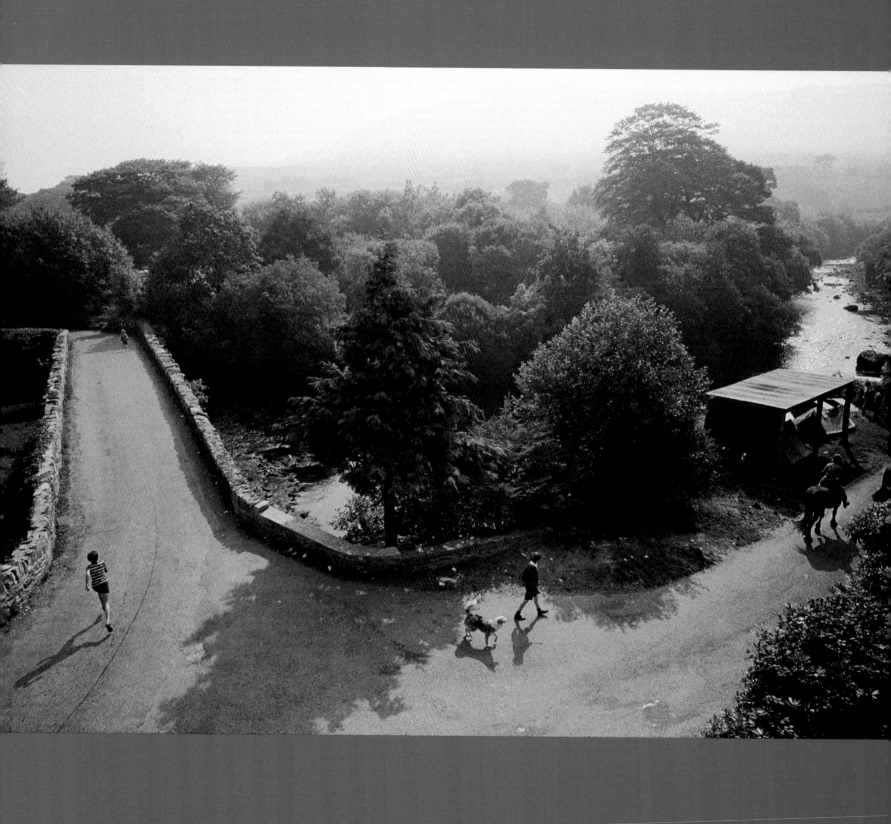

A Note

The obvious secret of Jill Freedman's genius is the simplicity of the composition of her photographs. Looking at the pictures, there isn't a one of us who doesn't say that I could have done that, but then on reflection we have to admit that we didn't think of it: Therein is the art of this extraordinary artist—she was there, and she thought of it. ¶ Jill never loses sight of the fact that she is a storyteller, whether standing from the rear (end of an elephant) to the face of a grime-covered fire fighter to a child running across a bridge. In one picture the story is told—where they were, what they are doing, and where they will end up. Not for Jill Freedman the artsy-craftsy compositions of the delicate, white-fingered, indoor picture snapper, no sir. She is there in the manure, in the ashes, in the wreckage fully focused on telling what happens in life to living creatures. ¶ Any collection of Jill's photographs, indeed any one of her works should be treasured and proudly displayed. It's not often an eye the likes of Jill's is bestowed on human beings, so it behooves us to pay attention. ¶ **—Malachy McCourt**

Author's note

In the 1960s I was living in London, singing for my supper. I went over to Ireland for a traditional music festival and was bowled over by the sounds. I returned again in 1973 after I had at last found photography. Pictures were my music now, and the camera was so much smaller than a guitar. Again, I went to hear the music, and again I fell head-over-heels in love with the place and the people. For the people *are* the place, even though the beauty of the land is astounding. ¶ I loved the gentleness, the sweet shyness, the warm welcomes and farewells, the soda bread warm from the hearth, and always a sup to eat. Guinness fresh as mother's milk, all the nutritional benefits of dark amber whiskey. The pleasure they had in welcoming a stranger who left a friend. ¶ Each time I return, I see the changes, the ugly, noisy modern world intruding, but I seek out the old ways; people making their own music, the high art of conversation in a good pub, milk churns driven by donkey cart to the dairy, gathering the hay, fair days in small towns. These are mostly gone now, replaced by machines, co-ops, and auctions. ¶ Each visit makes me more driven to record this traditional life. Like those who collect stories from the shannachies, or storytellers, I am collecting moments. For who will remember the old ways? ¶ I think of my work in Ireland as a love poem: a celebration of the beauty of the land, the warmth of her people, the simplicity of the old ways and traditions, the humor and conviviality, the sharp wit and black moods, the kindness. Today our vision of that country is colored by the violence in the North or the visual clichés: freckled kids in Irish sweaters, all those green, green fields. It is an older, gentler Ireland I am documenting, a wild and passionate beauty that feels like the last place on earth. For whatever changes time brings, Ireland ever will welcome you home with fiddles, pints, and a cow in a field. ¶ —**Jill Freedman**

CARRICK County Donegal

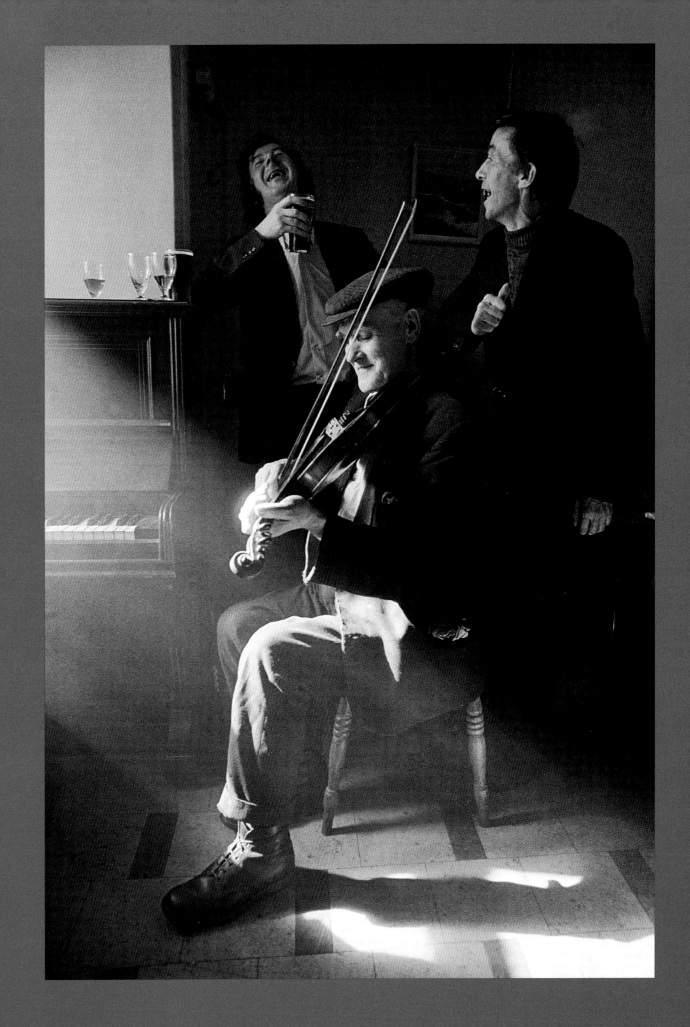

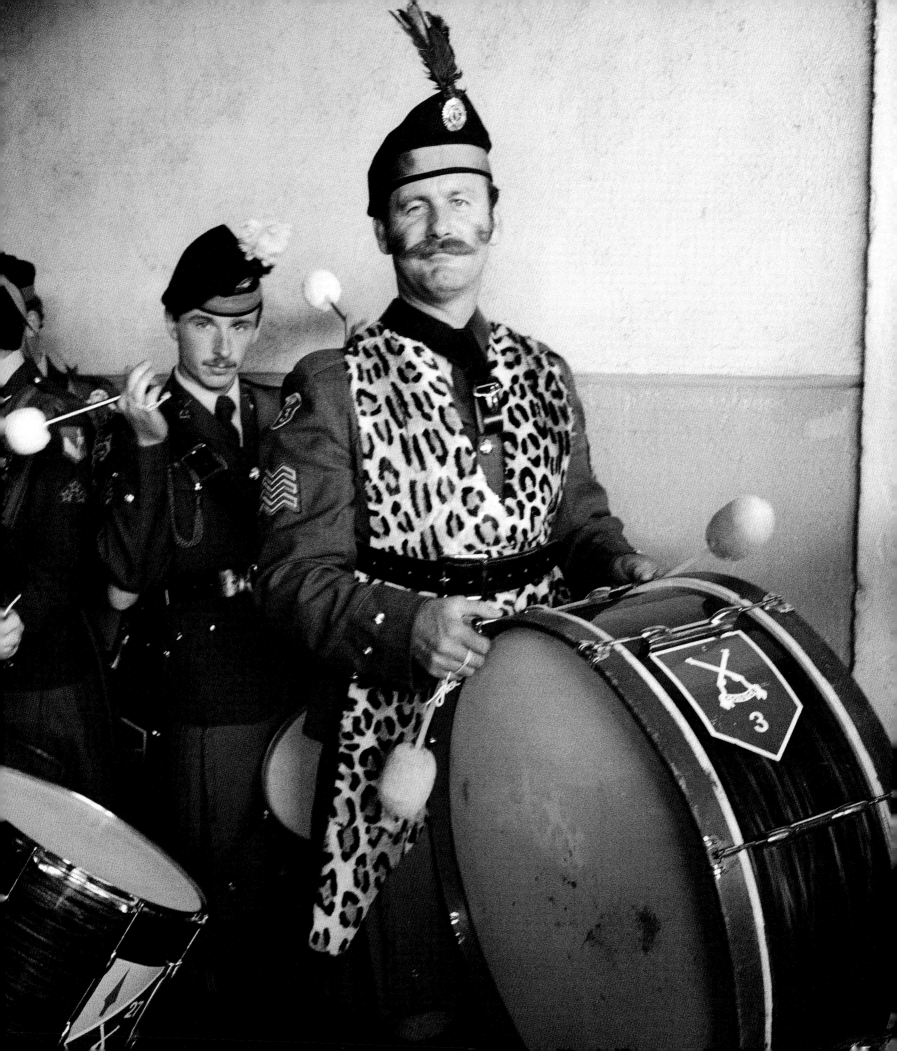

GNIVGUILLA County Kerry

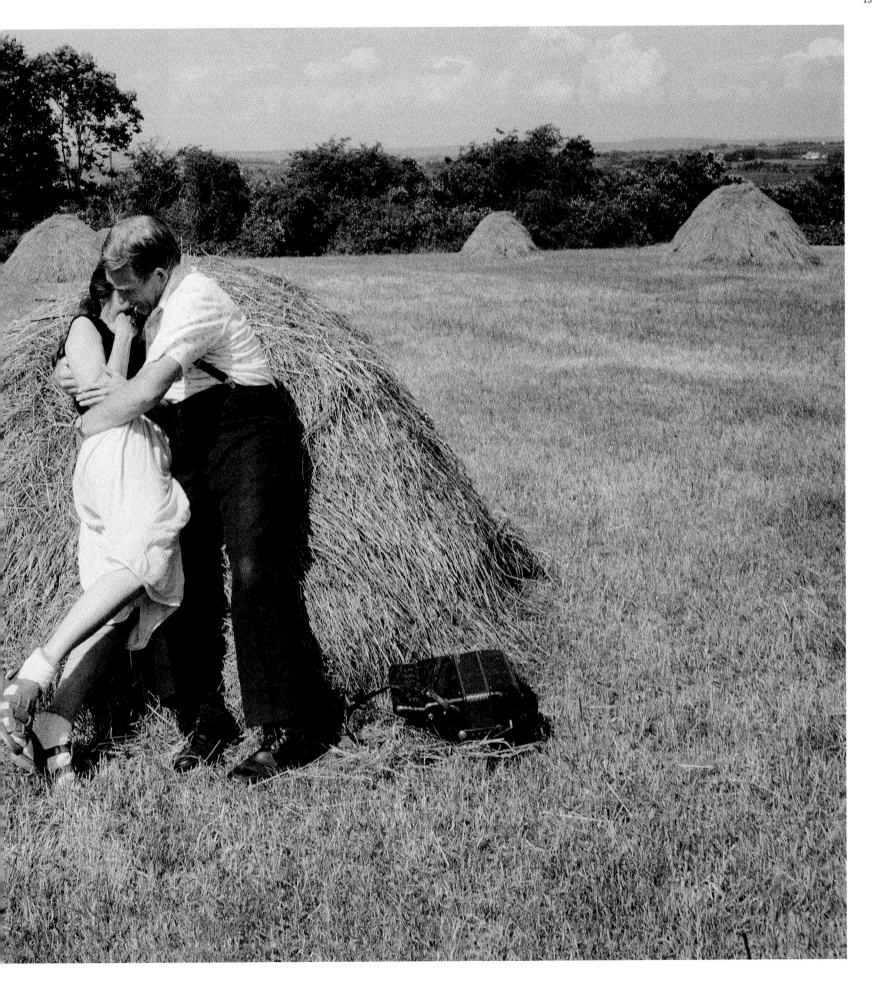

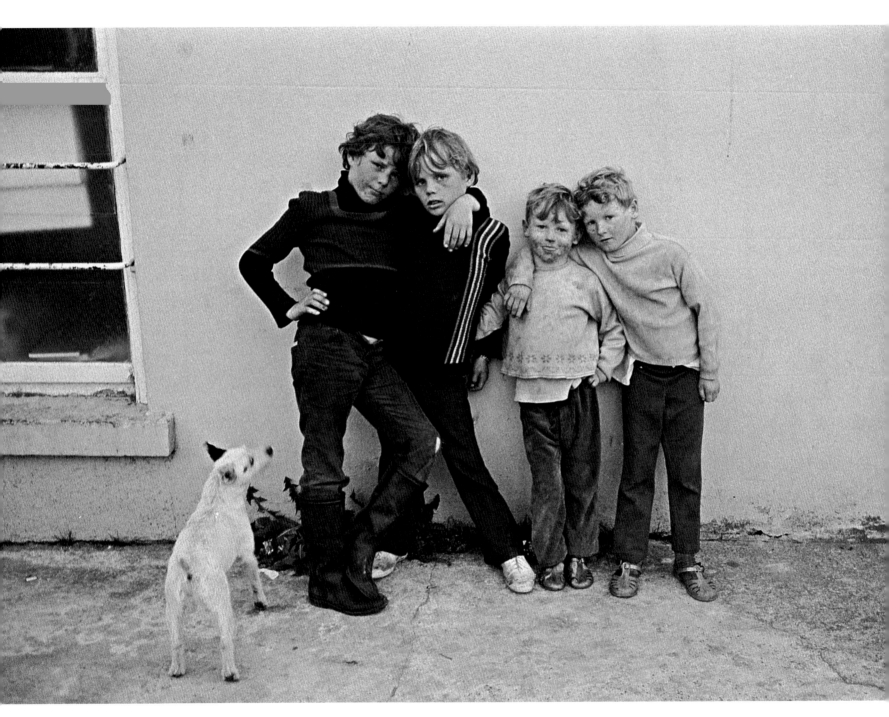

LISTOWEL County Kerry

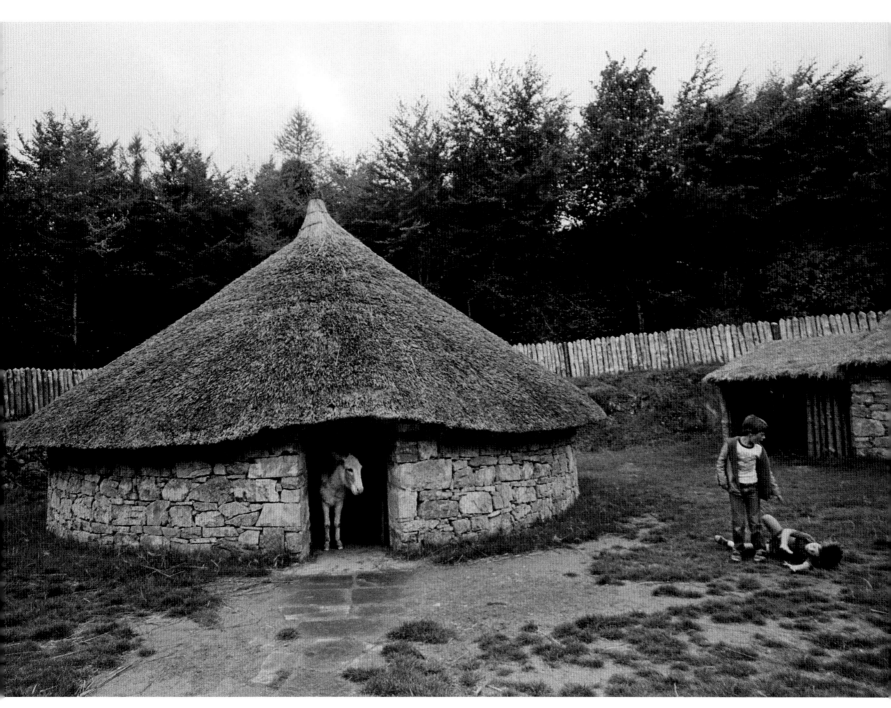

BUNRATTY FOLK PARK County Clare

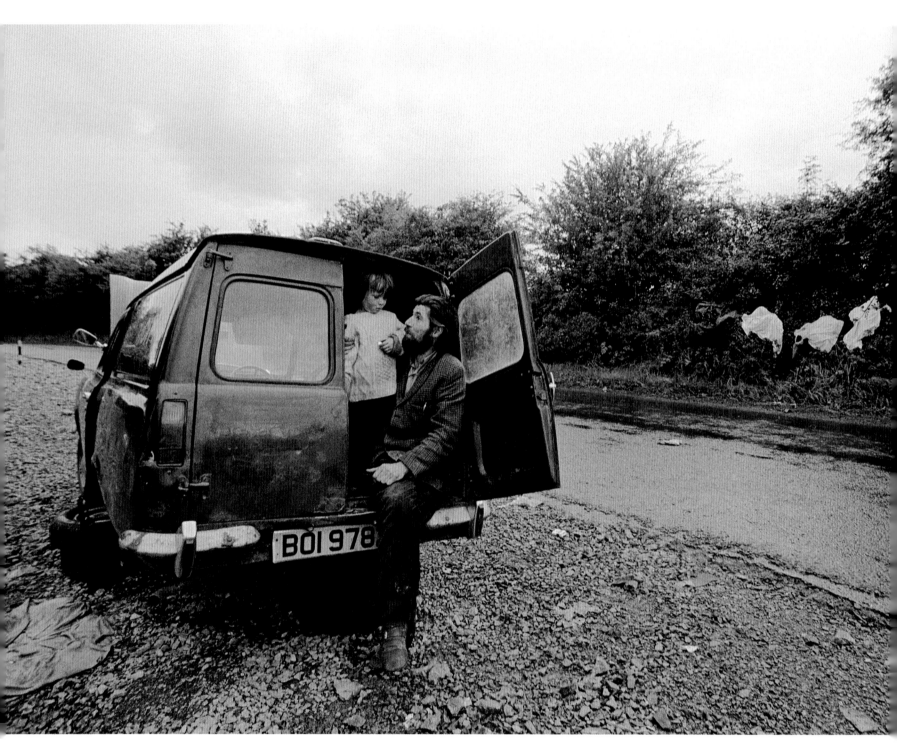

County Roscommon

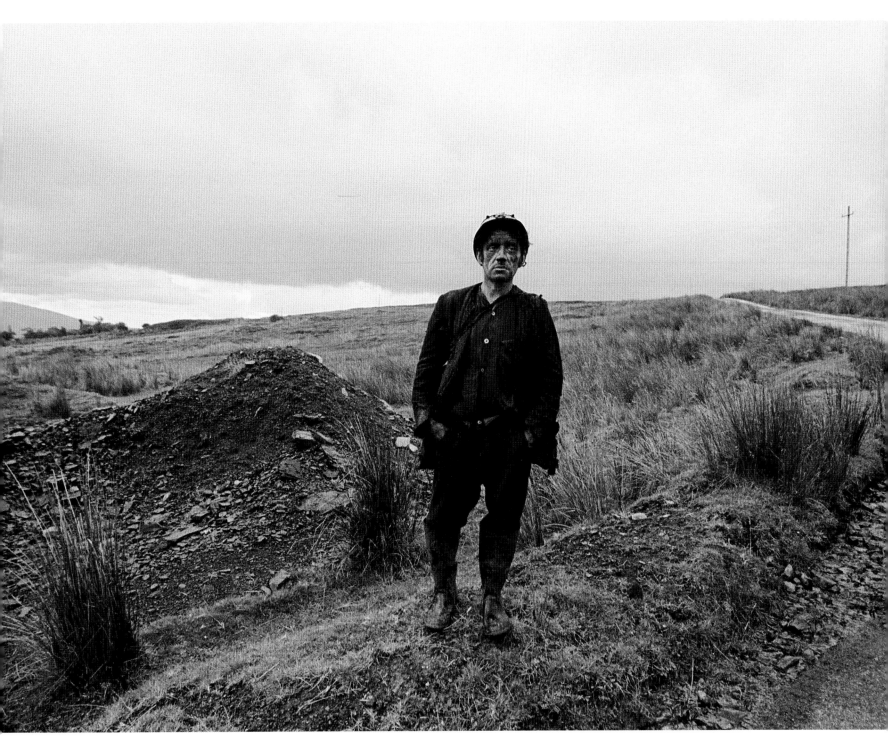

ARIGNA County Roscommon

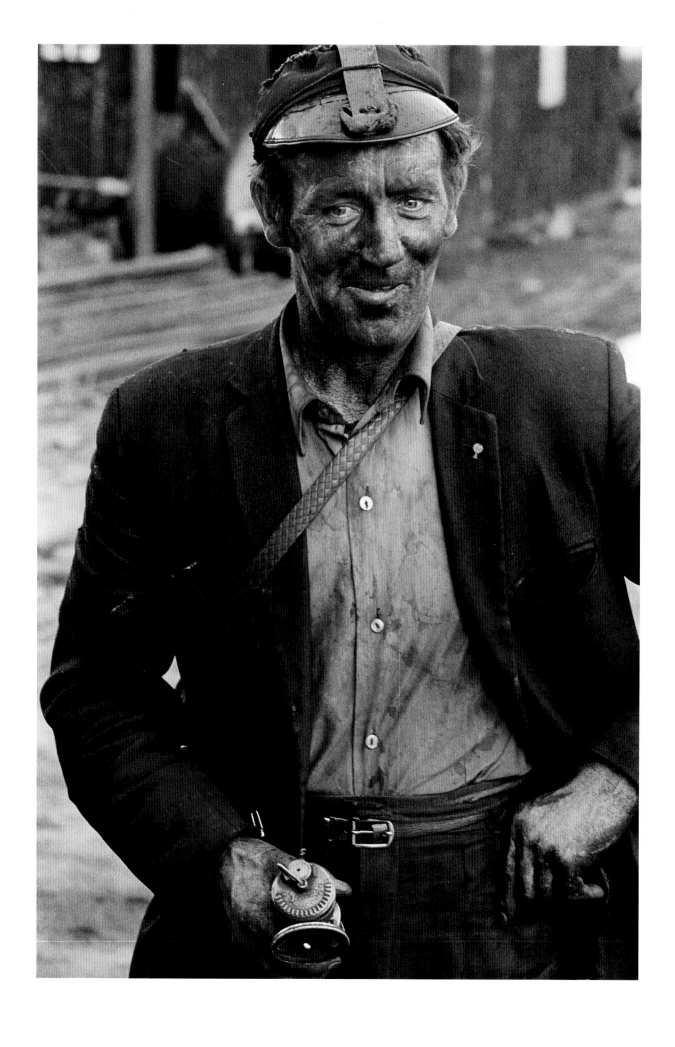

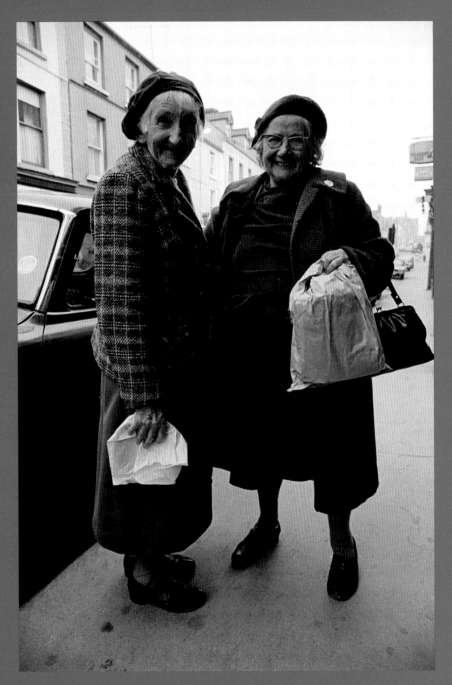

County Tipperary

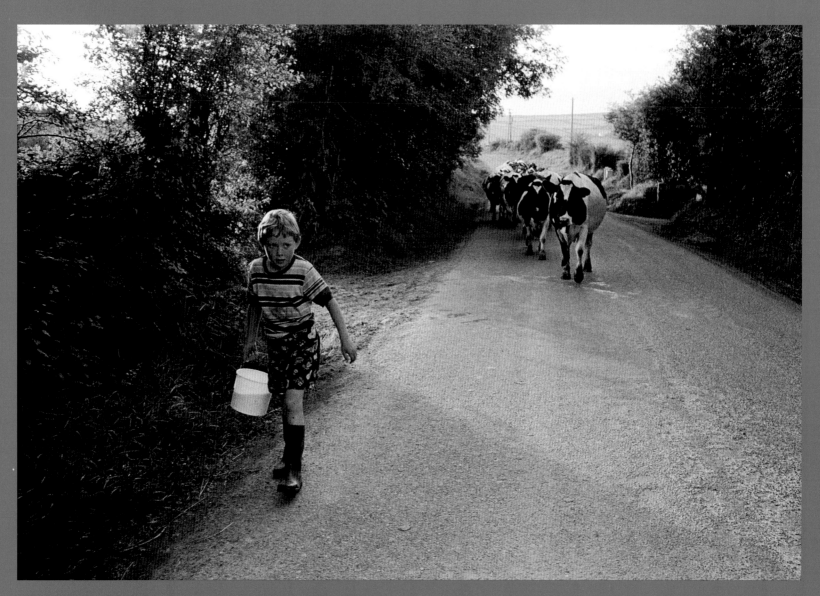

County Kerry

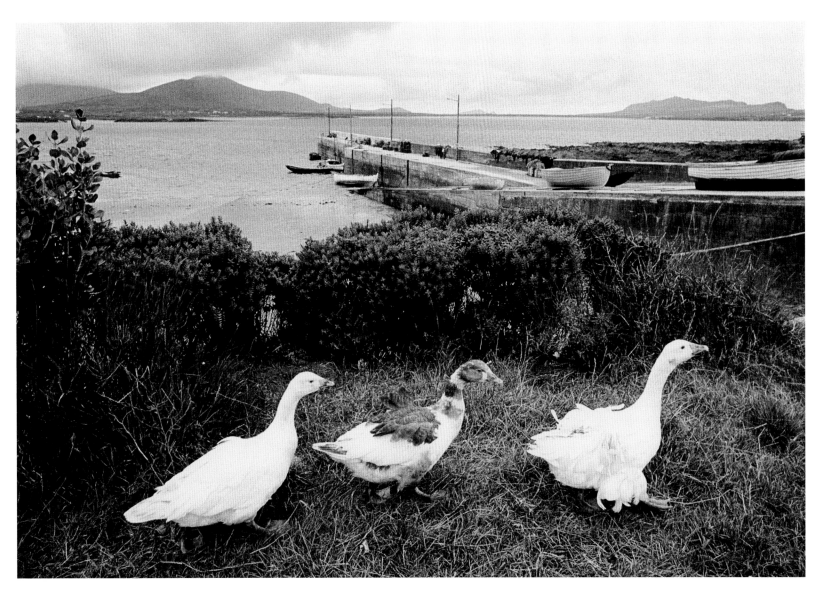

DINGLE County Kerry

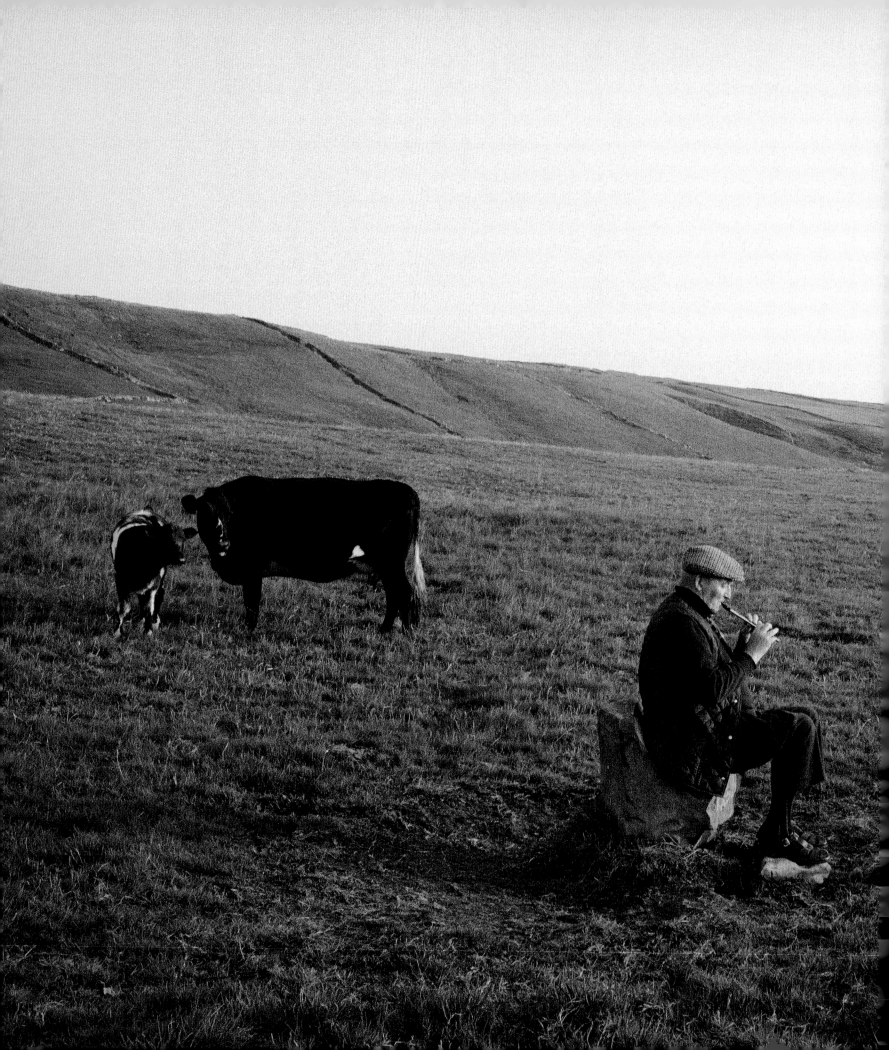

DOOLIN County Clare

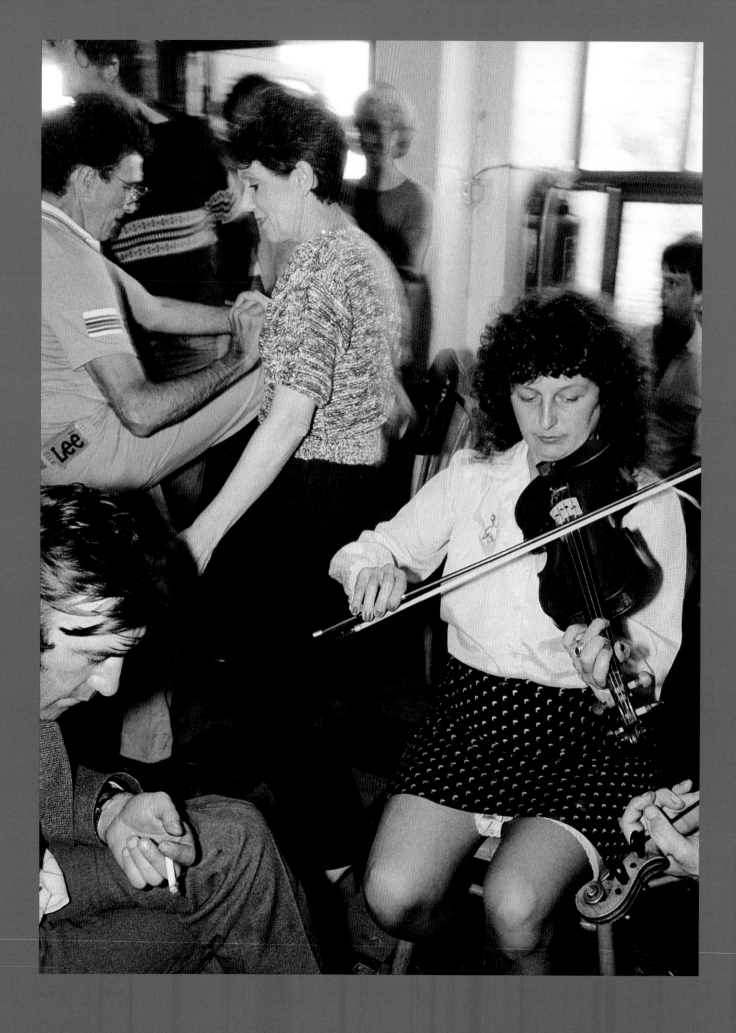

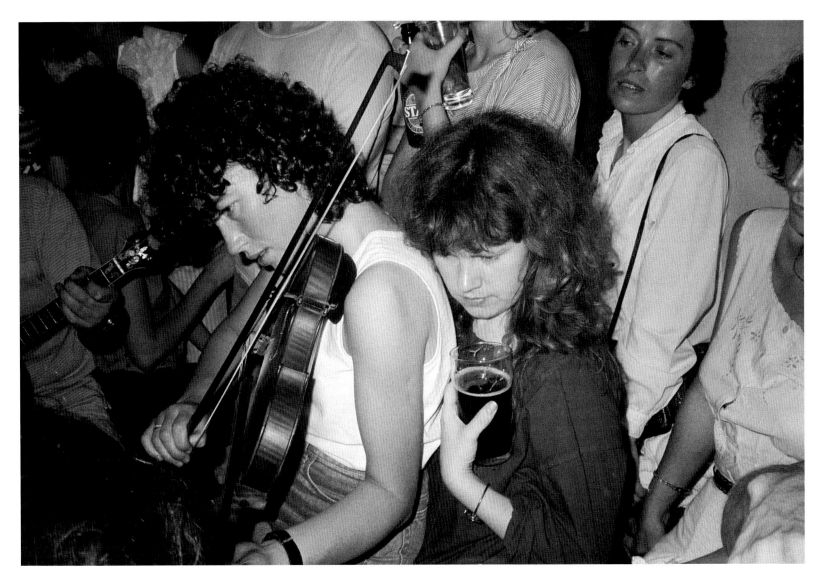

MULLAGH County Clare

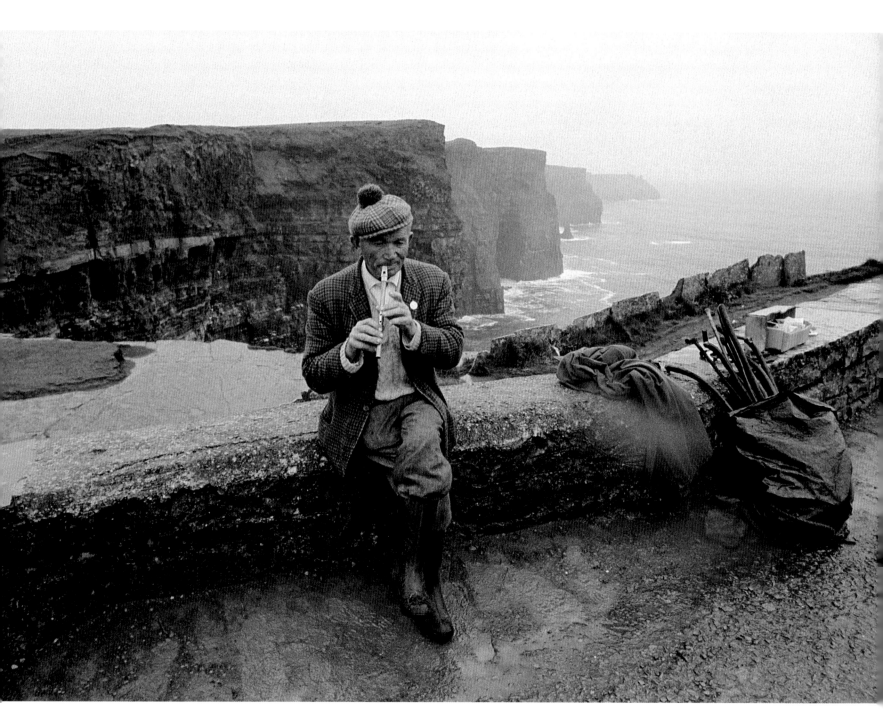

CLIFFS OF MOHER County Clare

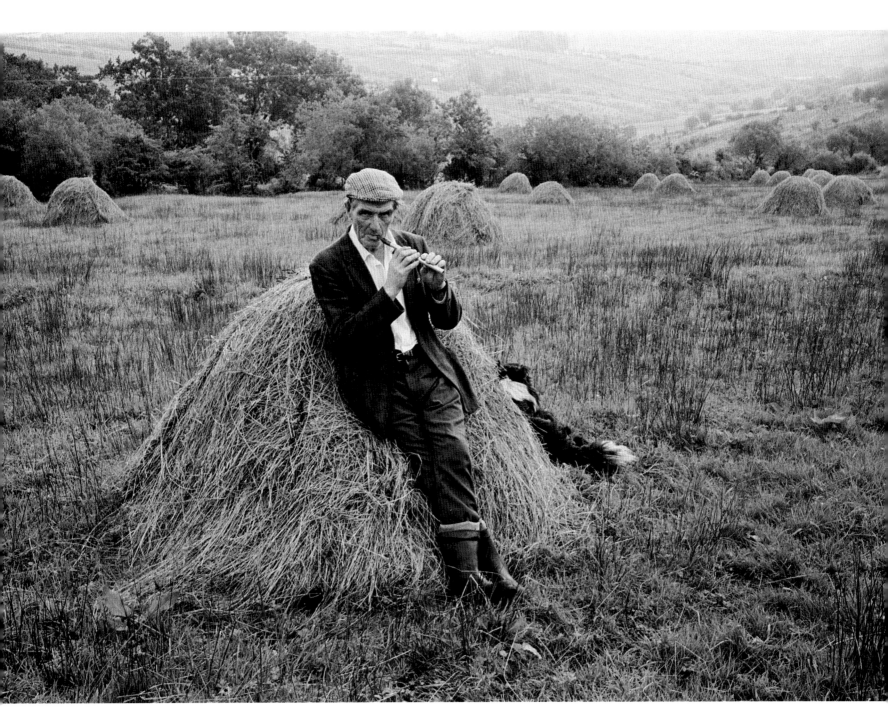

CREVELEA County Leitrim

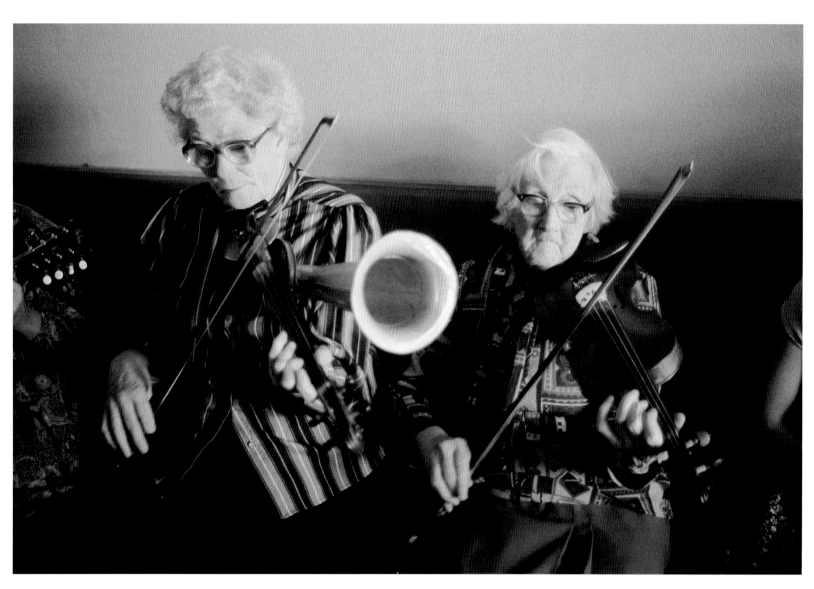

KNOCKNAGREE County Cork

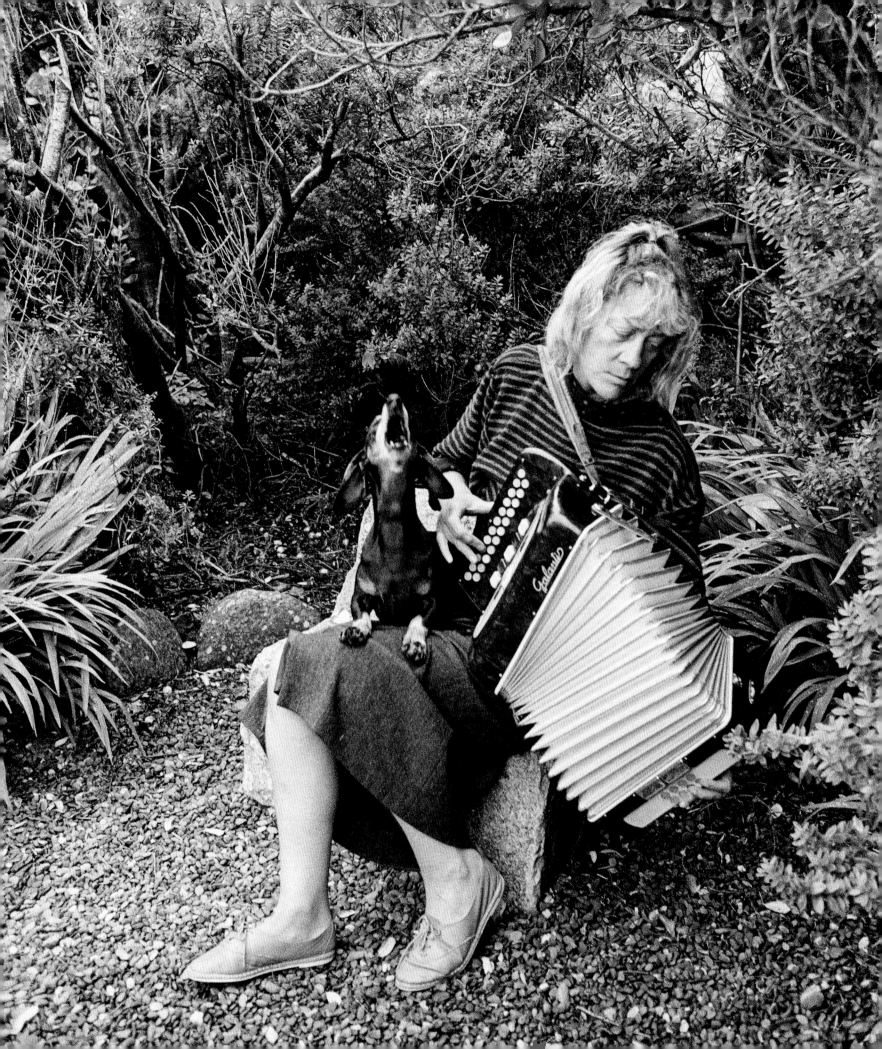

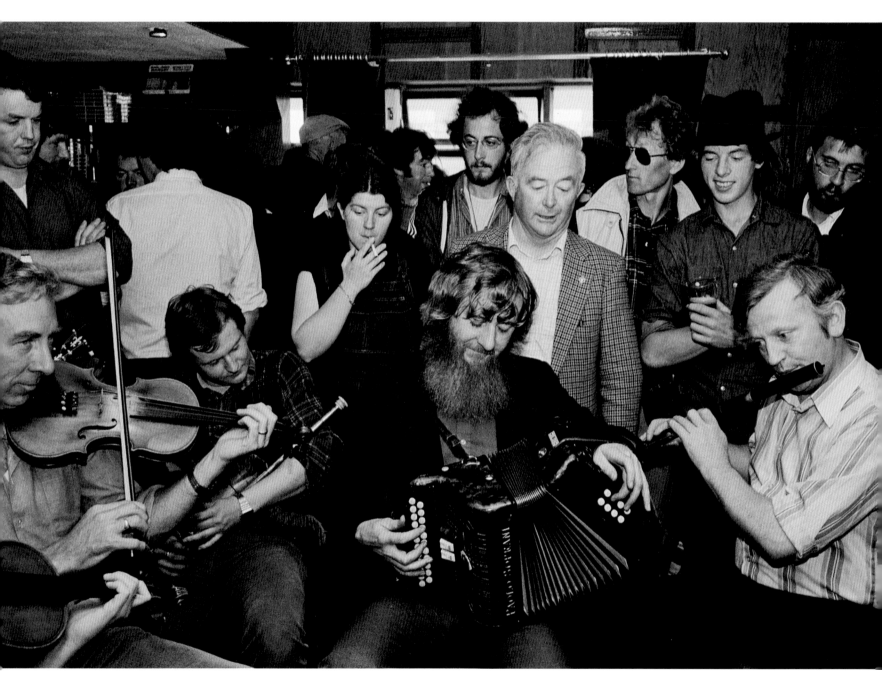

LISTOWEL County Kerry

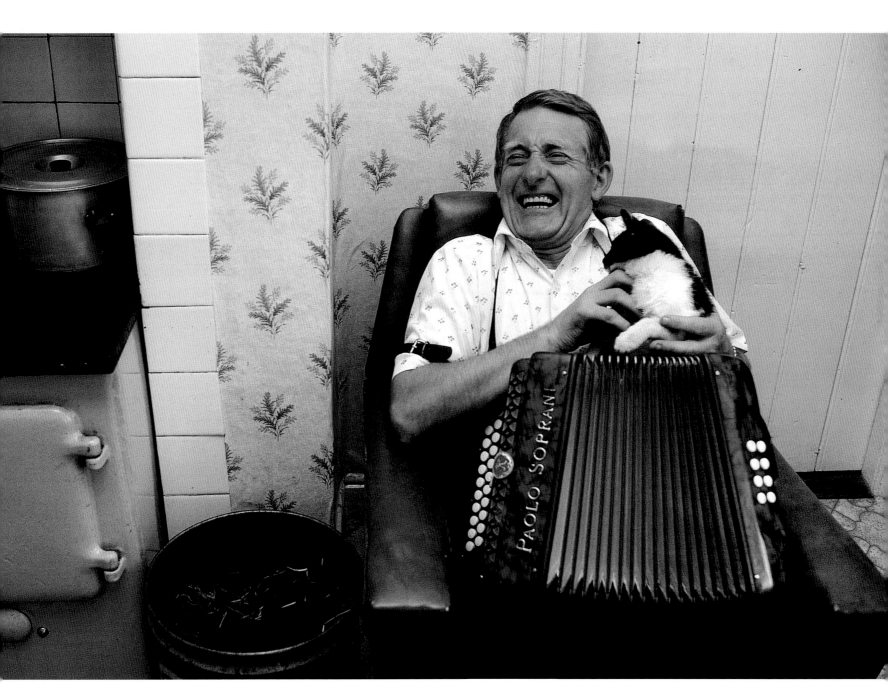

GNIVGUILLA County Kerry

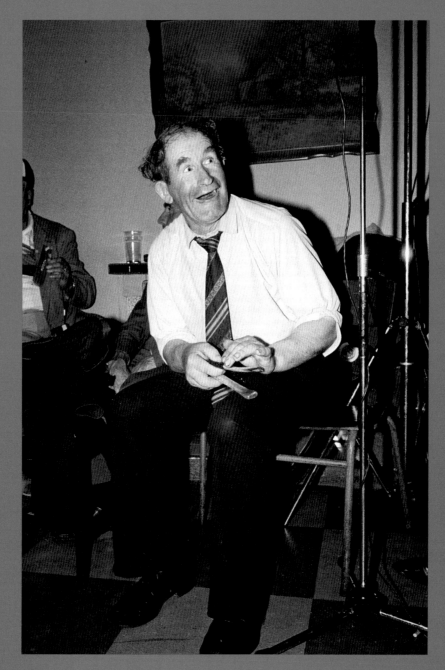

LISDOONVARNA County Clare

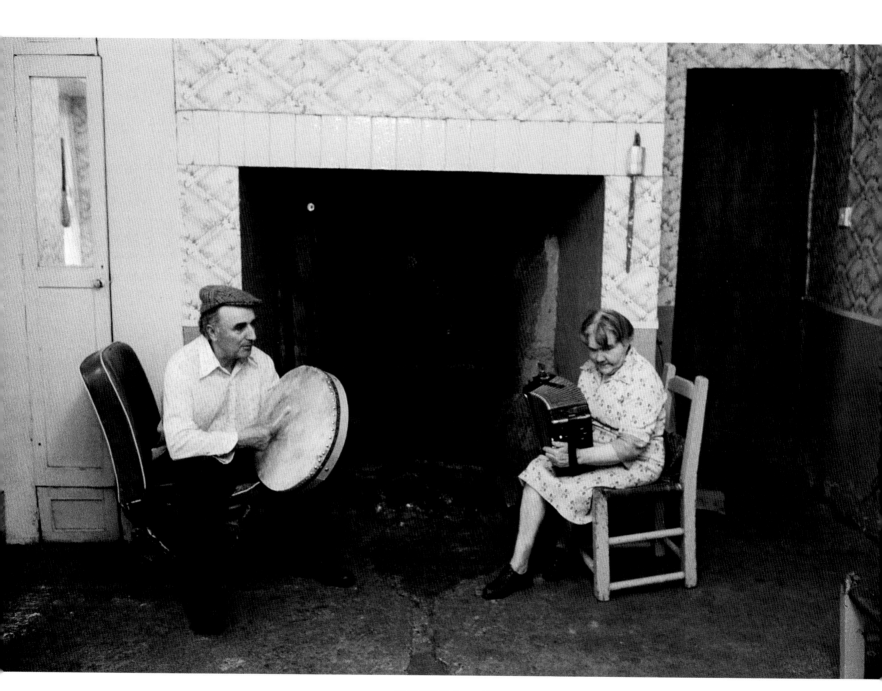

LISTOWEL County Kerry

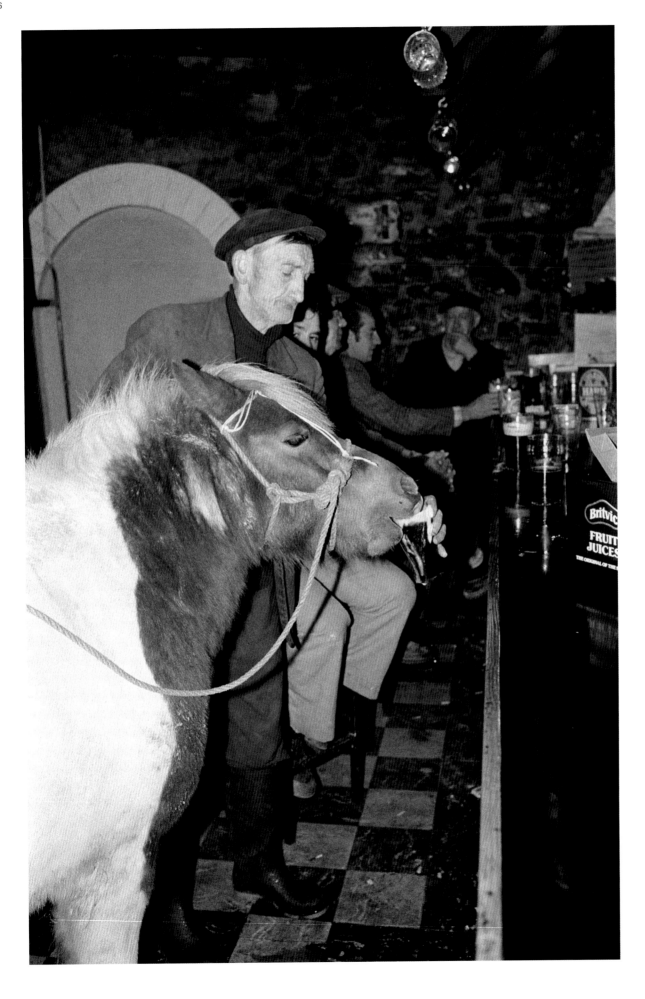

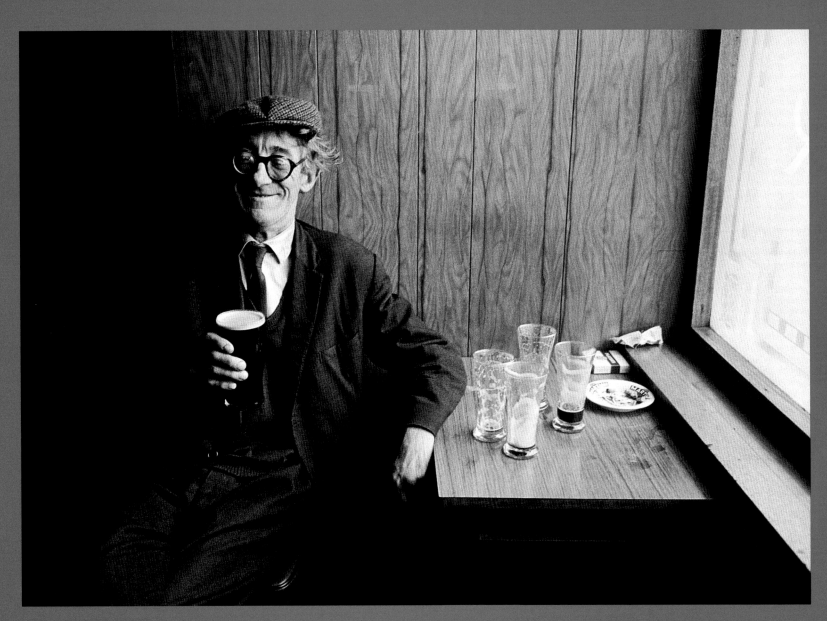

DRUMKEERAN County Leitrim

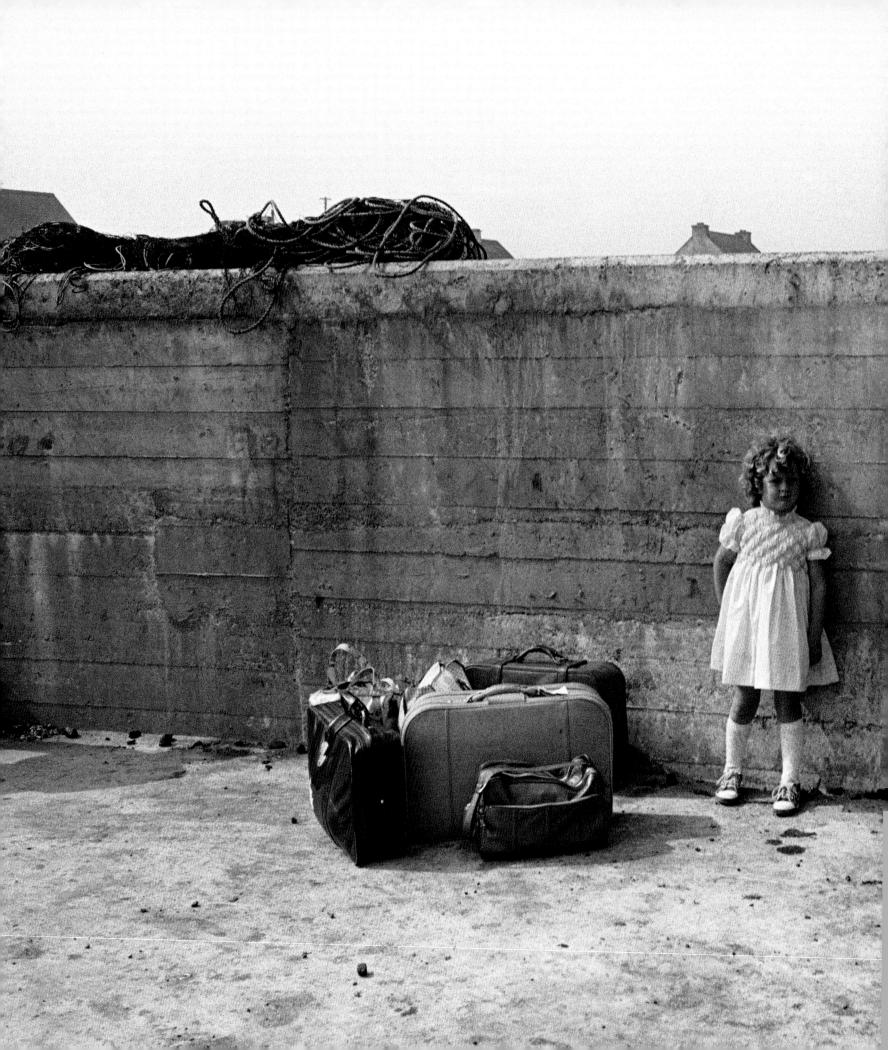

INISHEER Aran Islands

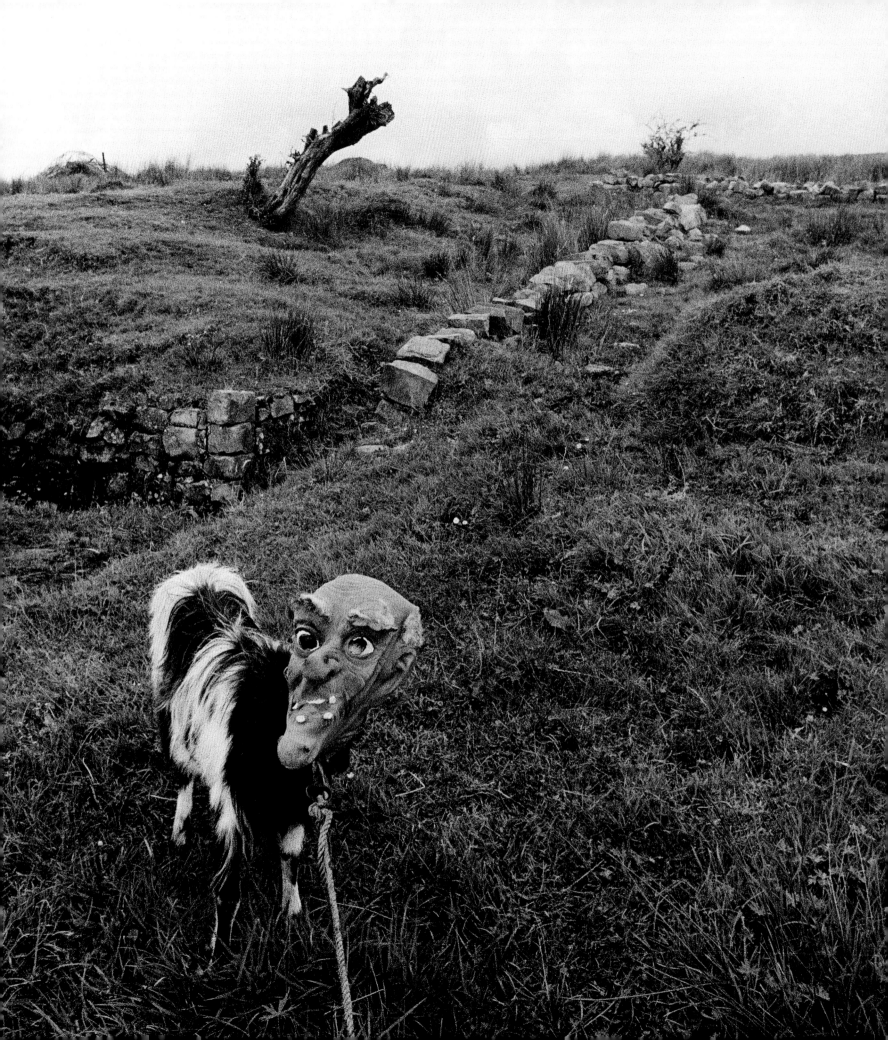

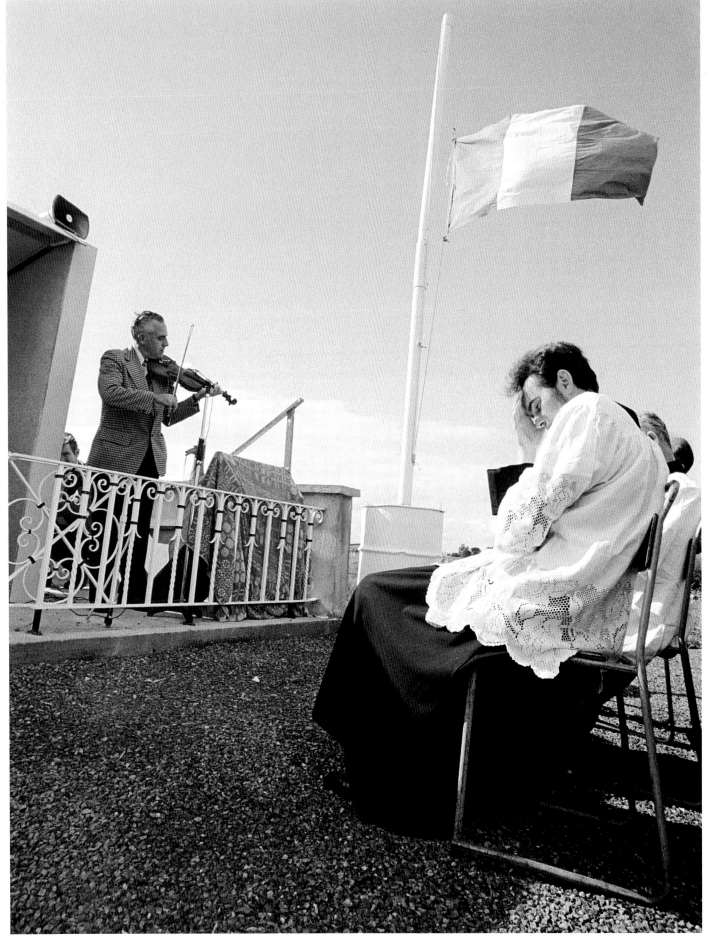

CREVELEA County Leitrim

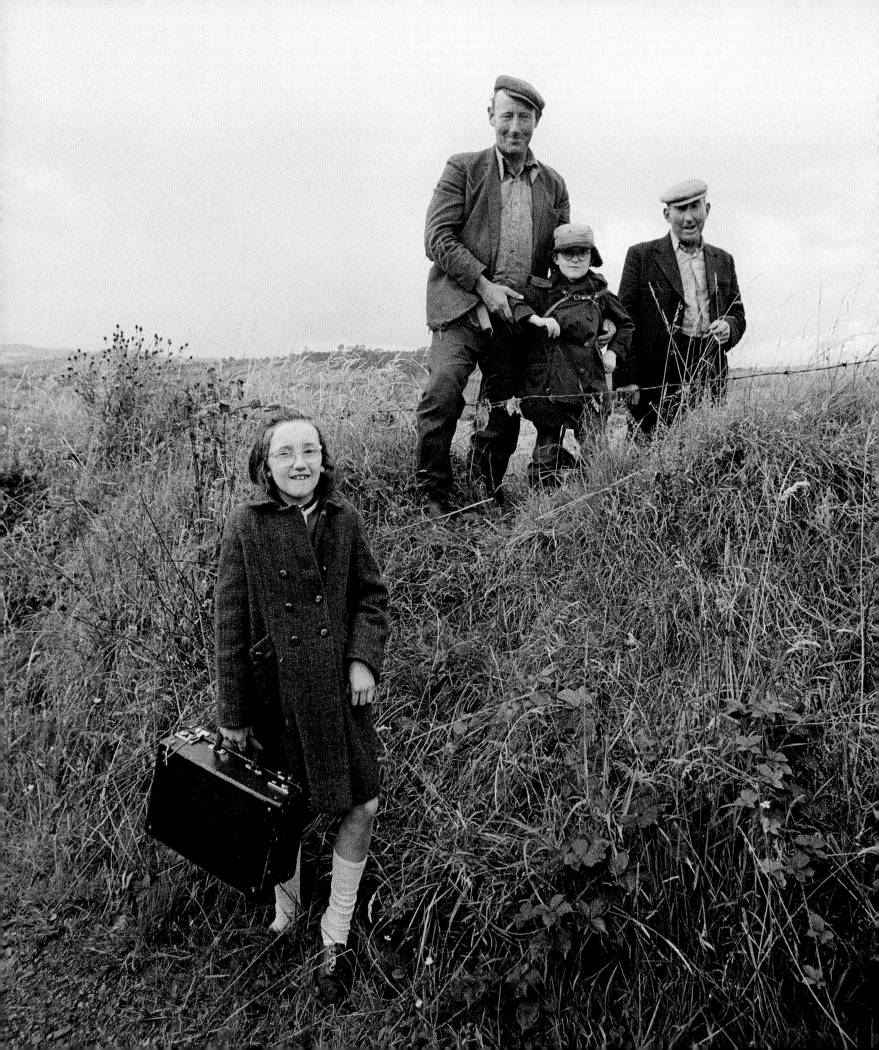

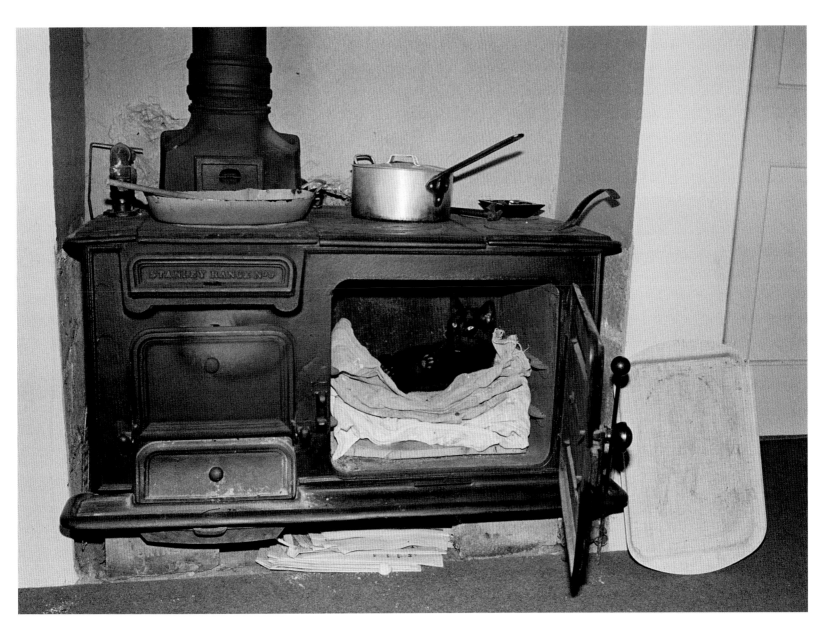

NEWMARKET-ON-FERGUS County Clare

GAEGLUM County Leitrim

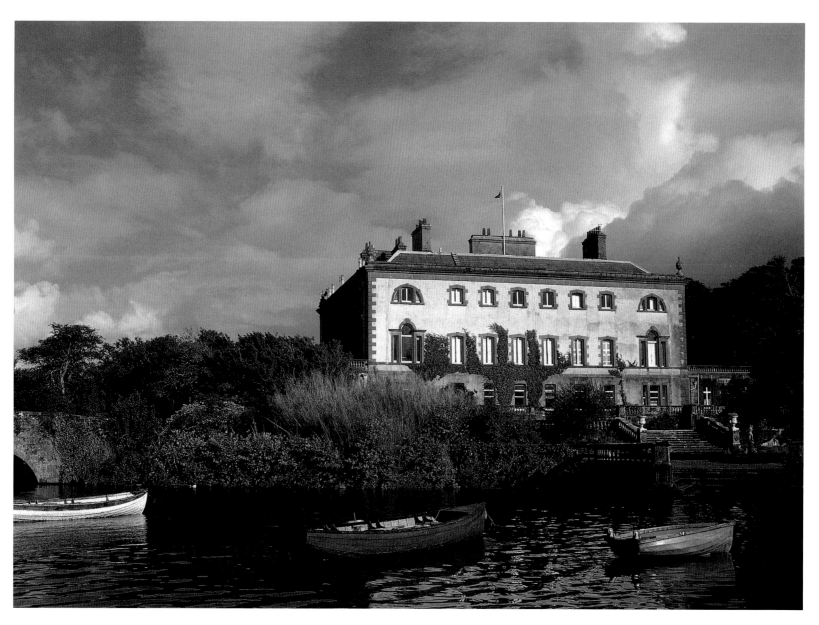

WESTPORT County Mayo

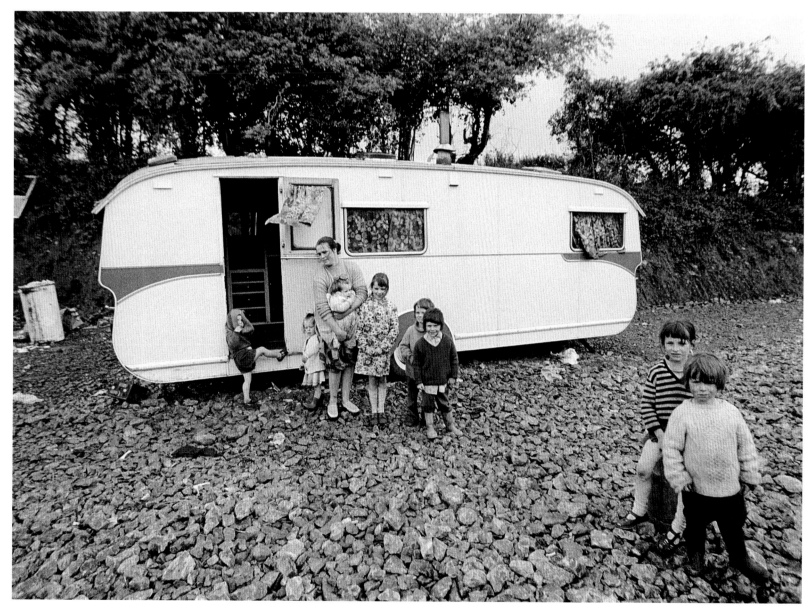

County Roscommon

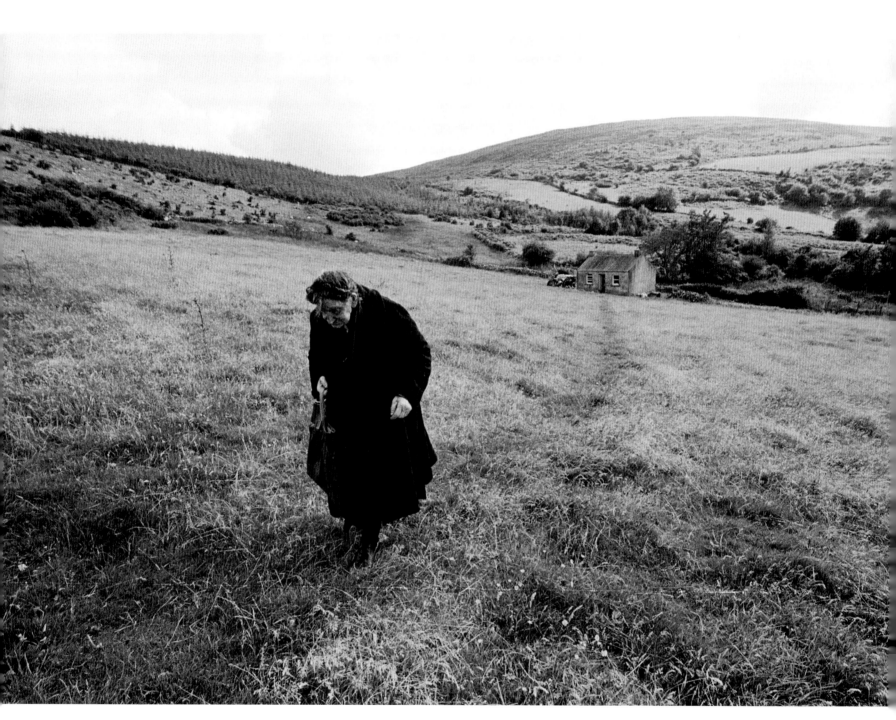

County Tipperary

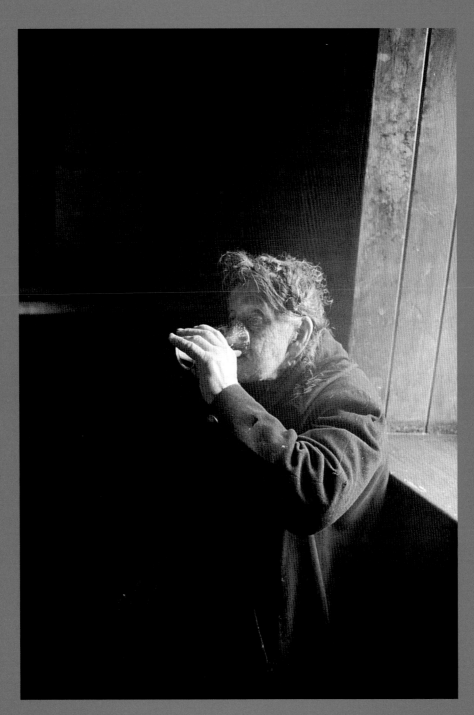

County Tipperary

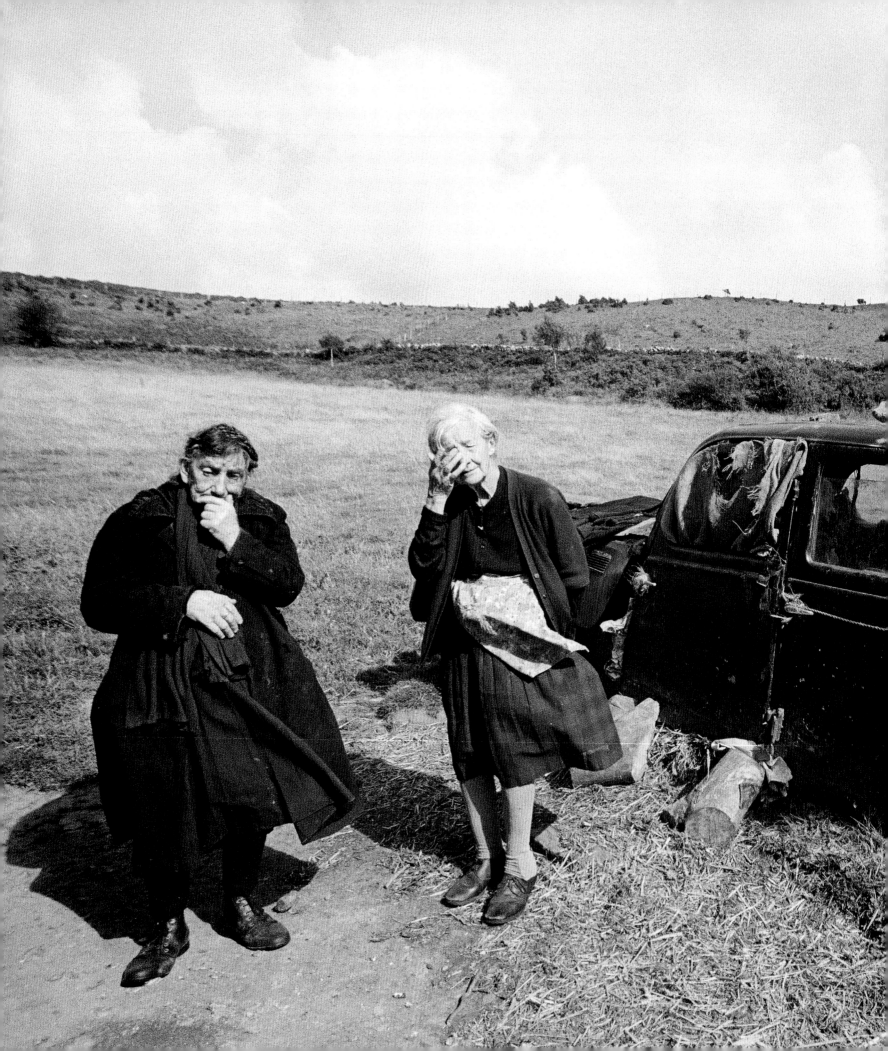

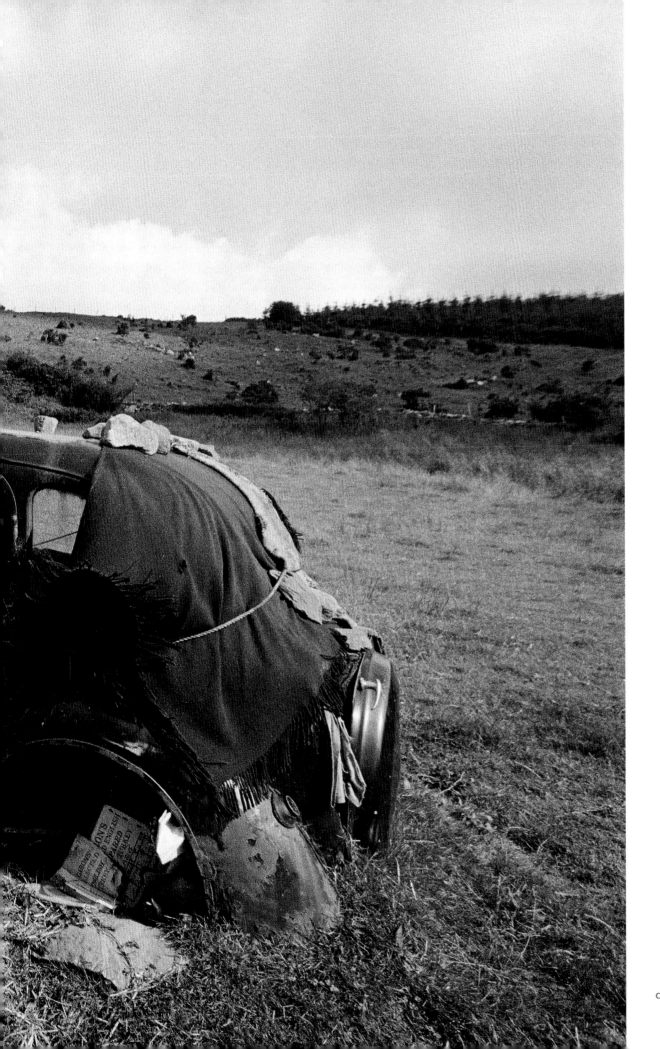

CHICKEN COOP County Tipperary

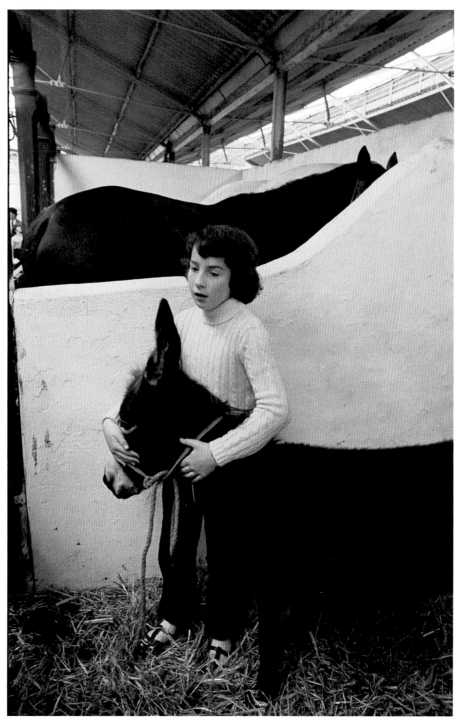

Dublin

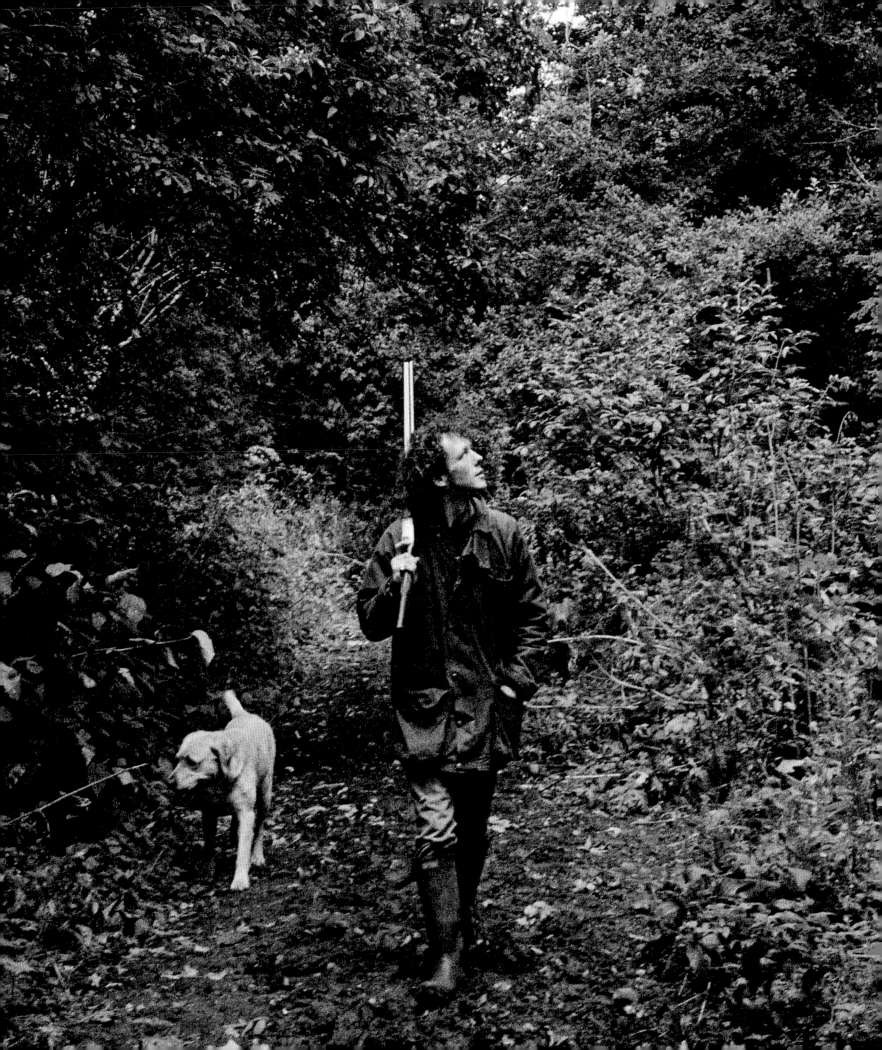

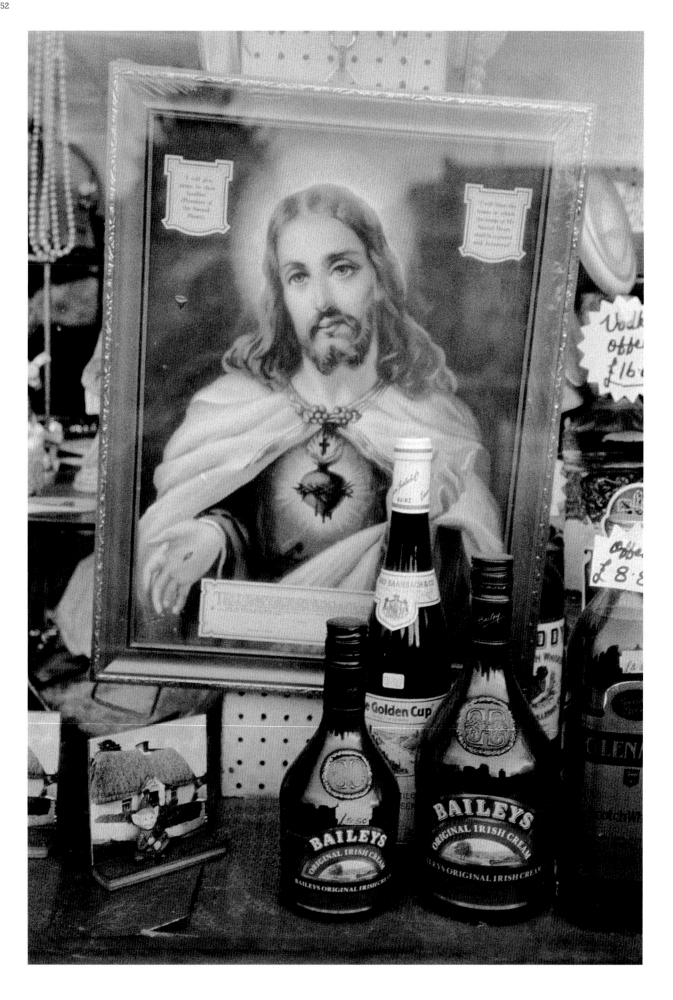

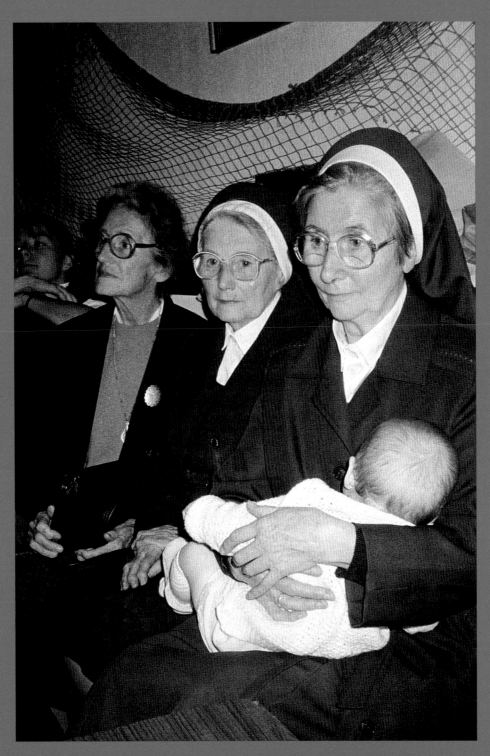

County Clare

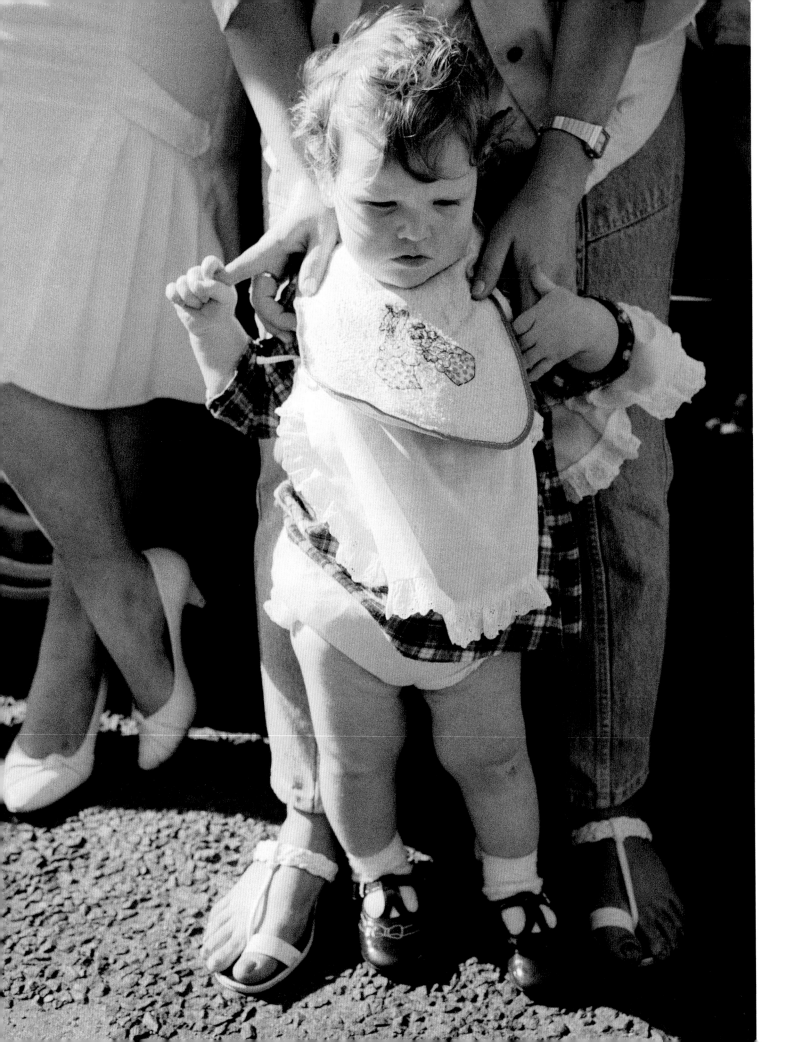

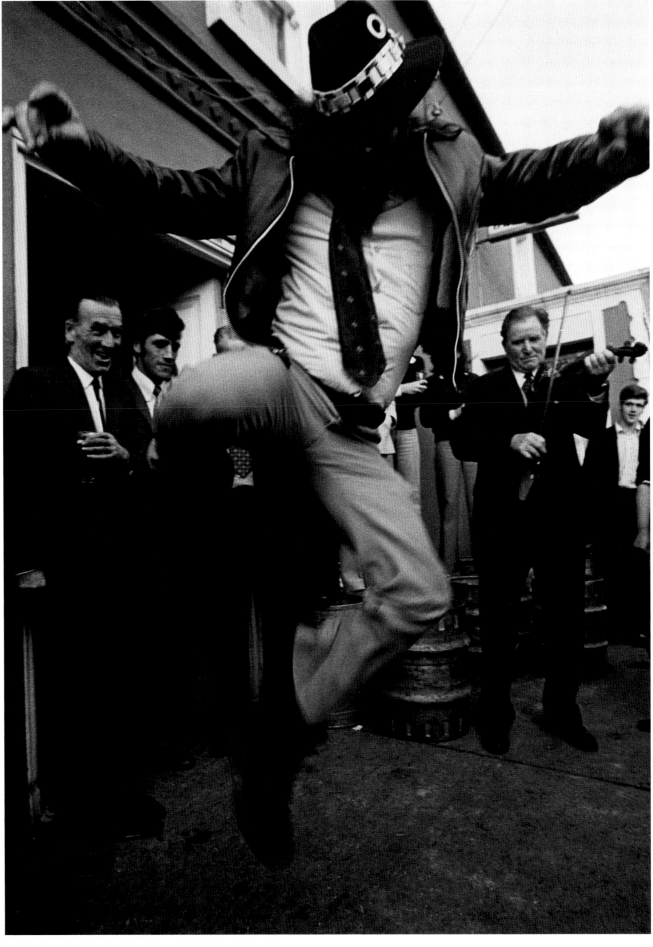

County Kerry

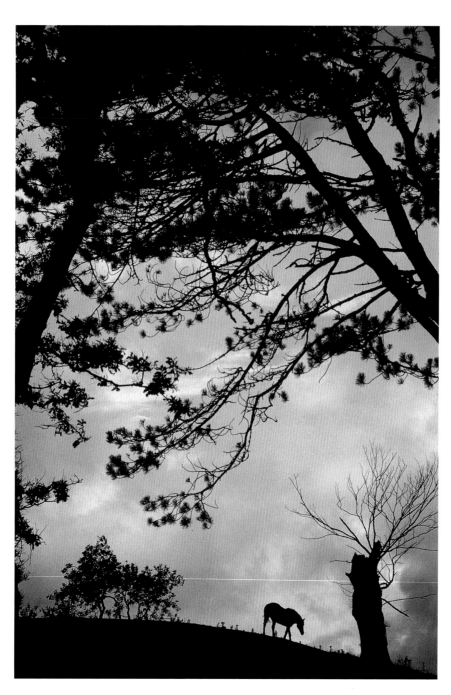

County Kildare

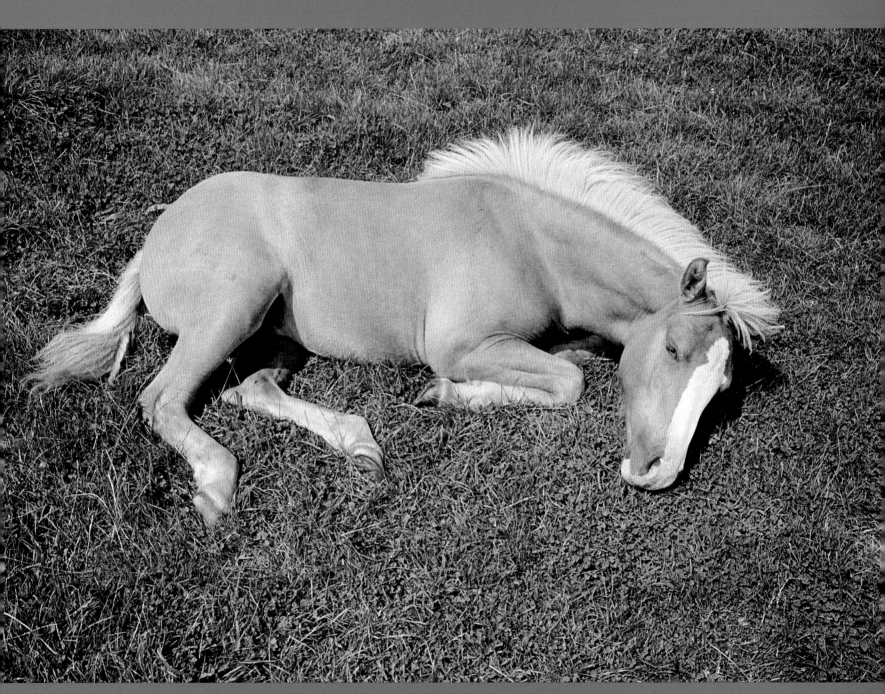

CONNEMARA County Galway

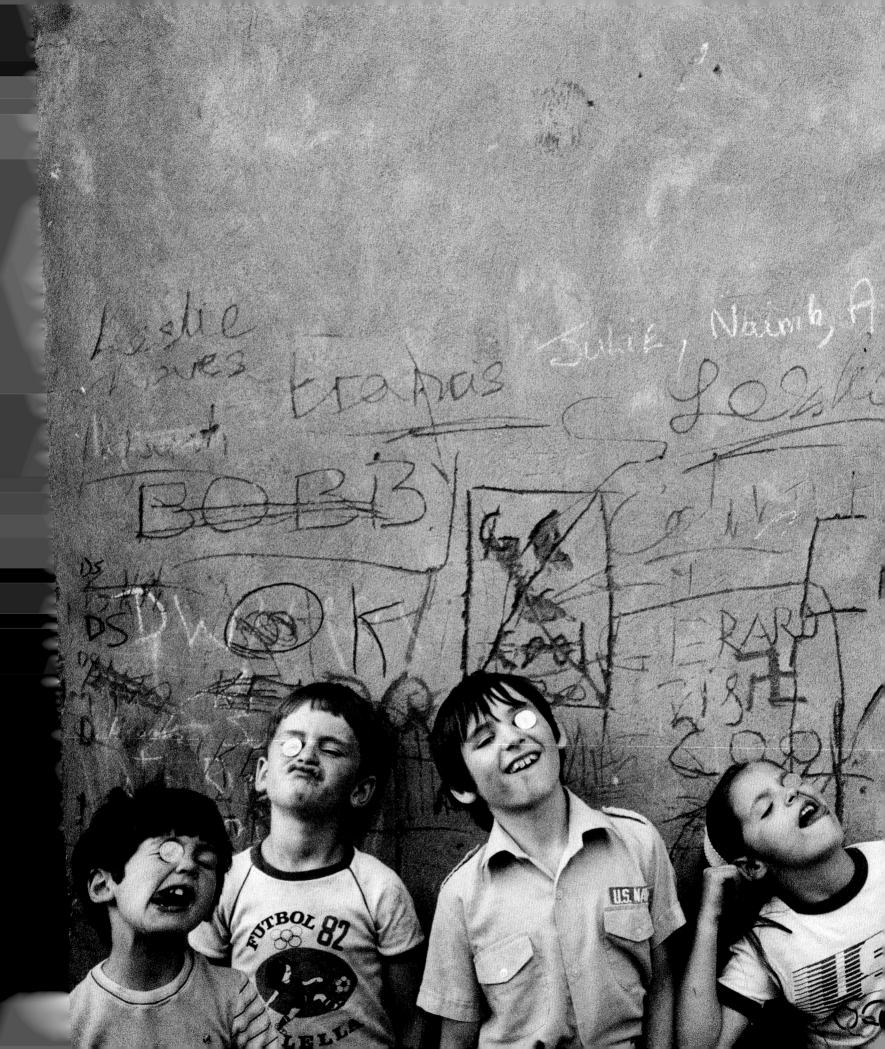

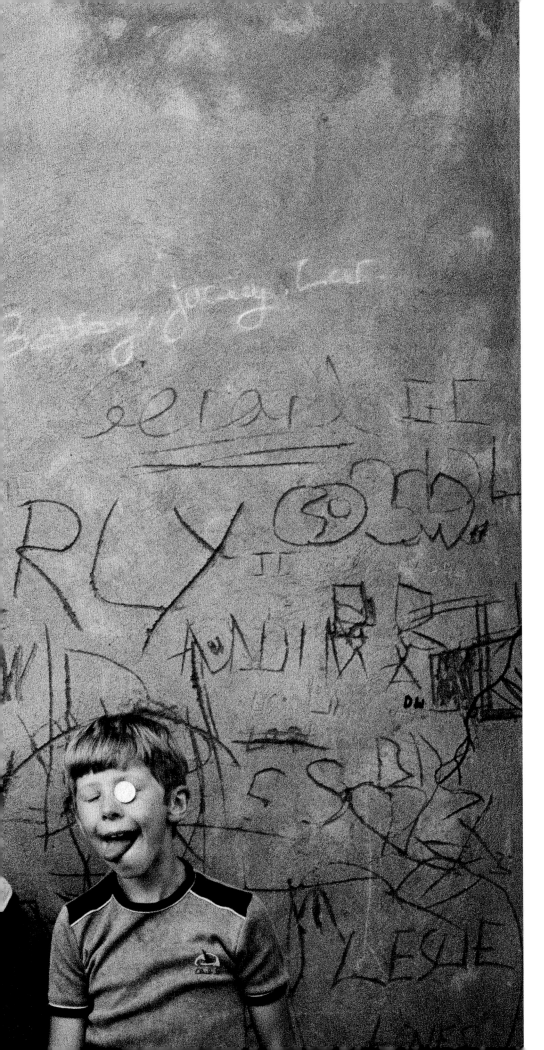

Dublin

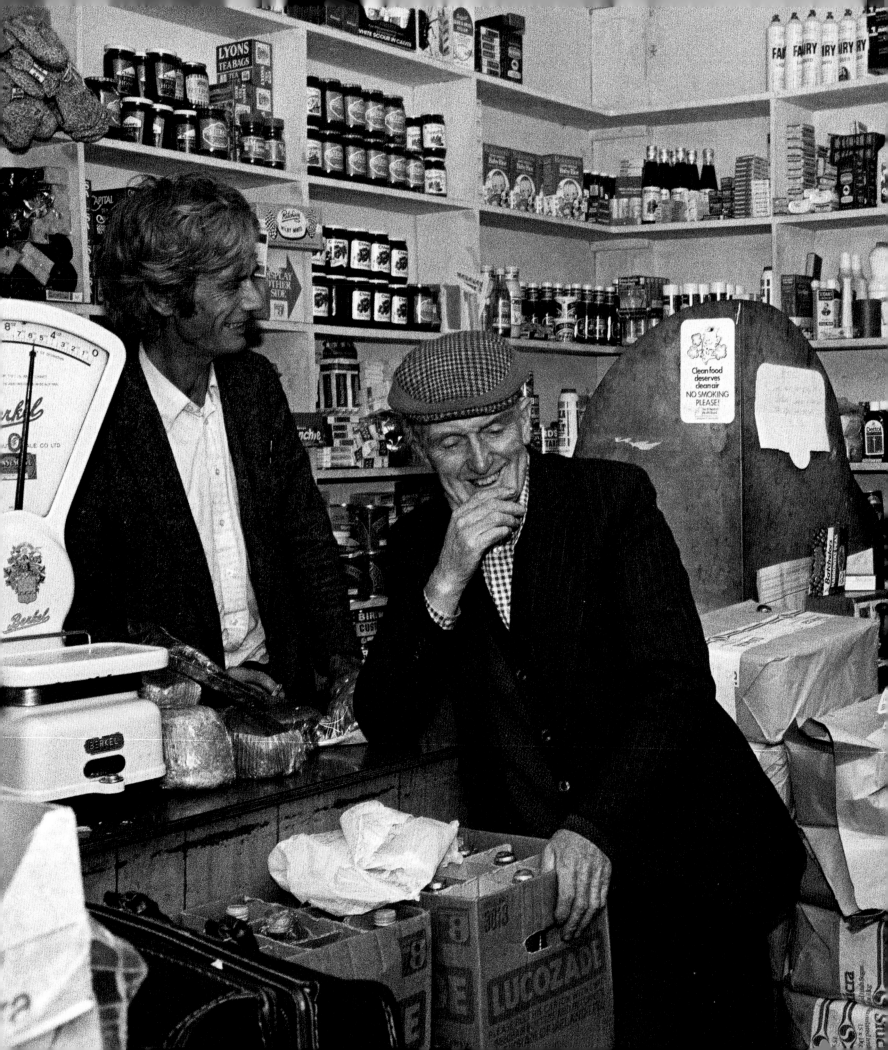

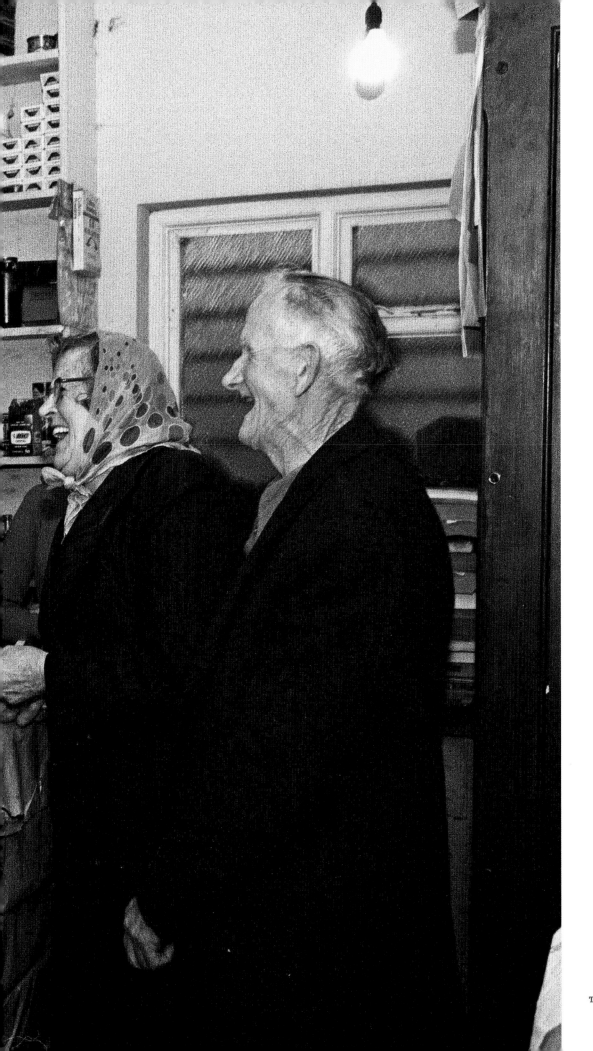

TAWNYLEA County Leitrim

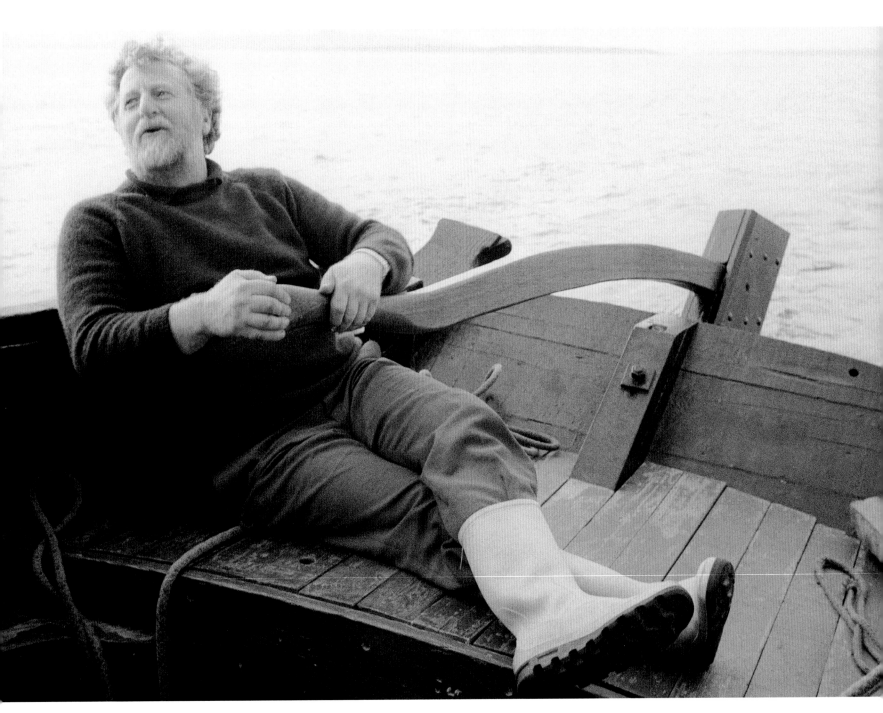

GALWAY BAY County Galway

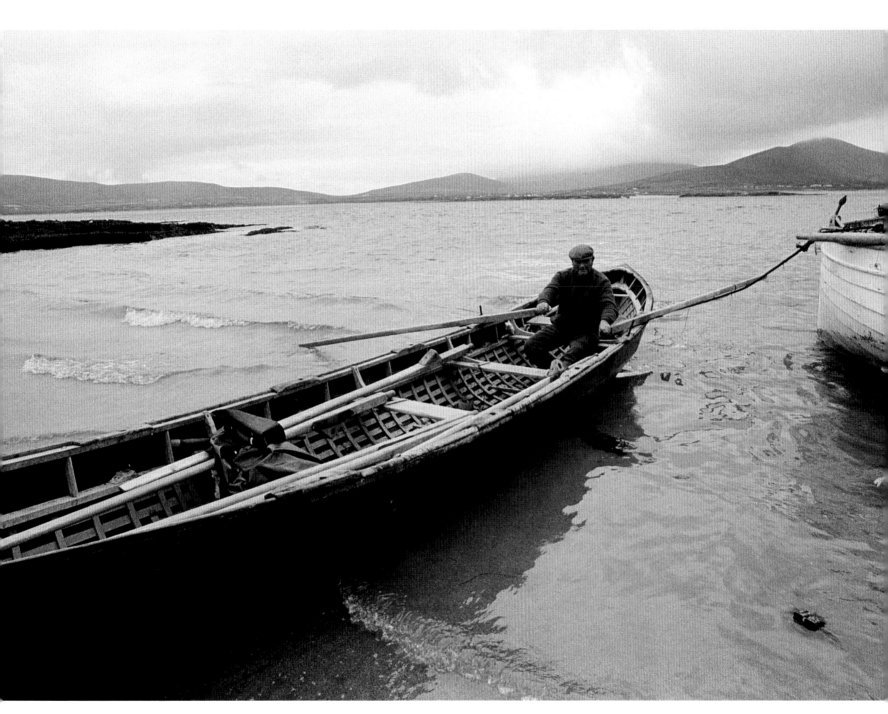

DINGLE County Kerry

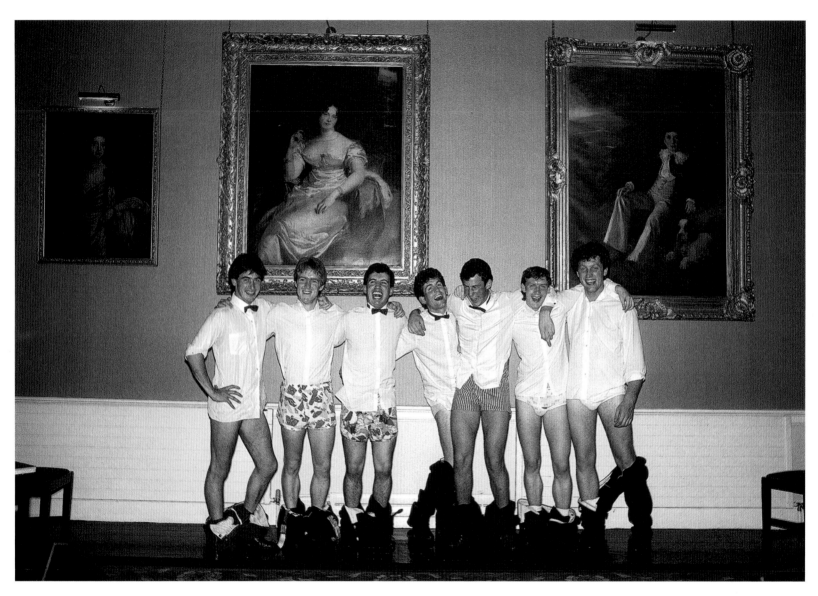

DUBLIN COLLEGE BALL County Meath

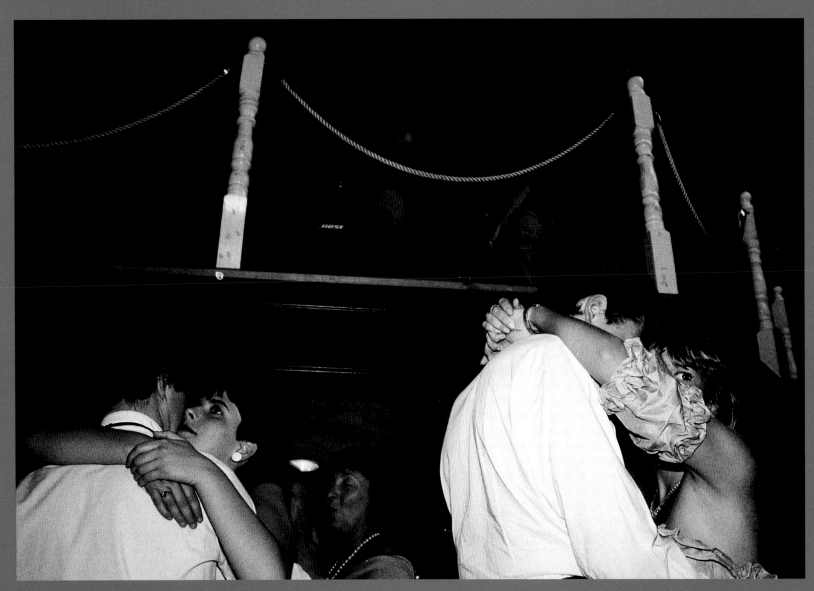

MEATH HUNT BALL Dublin

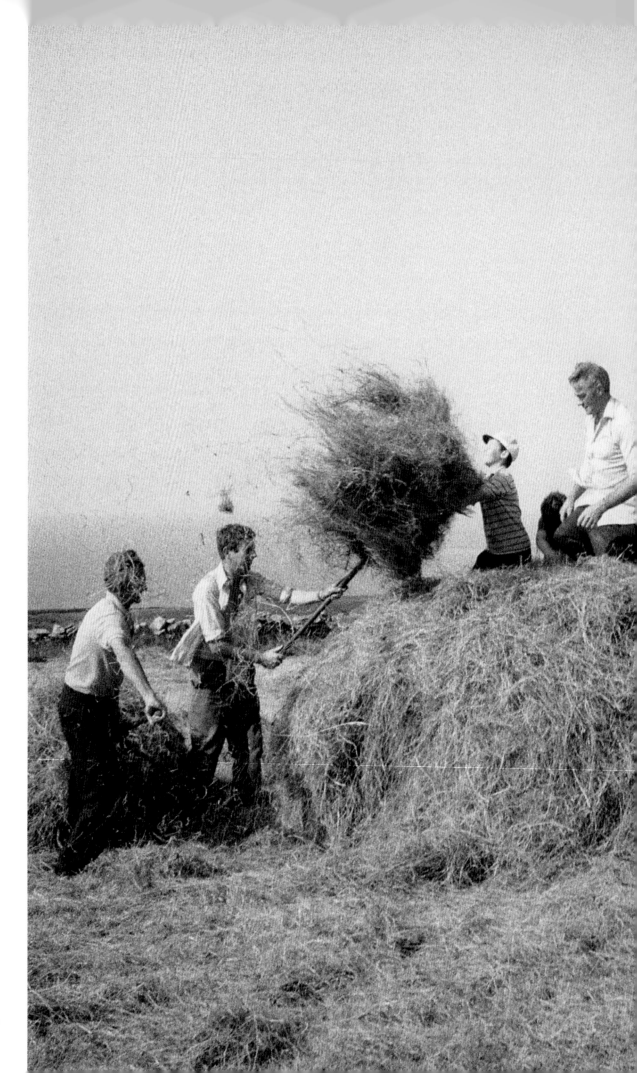

DOONAGORE County Clare

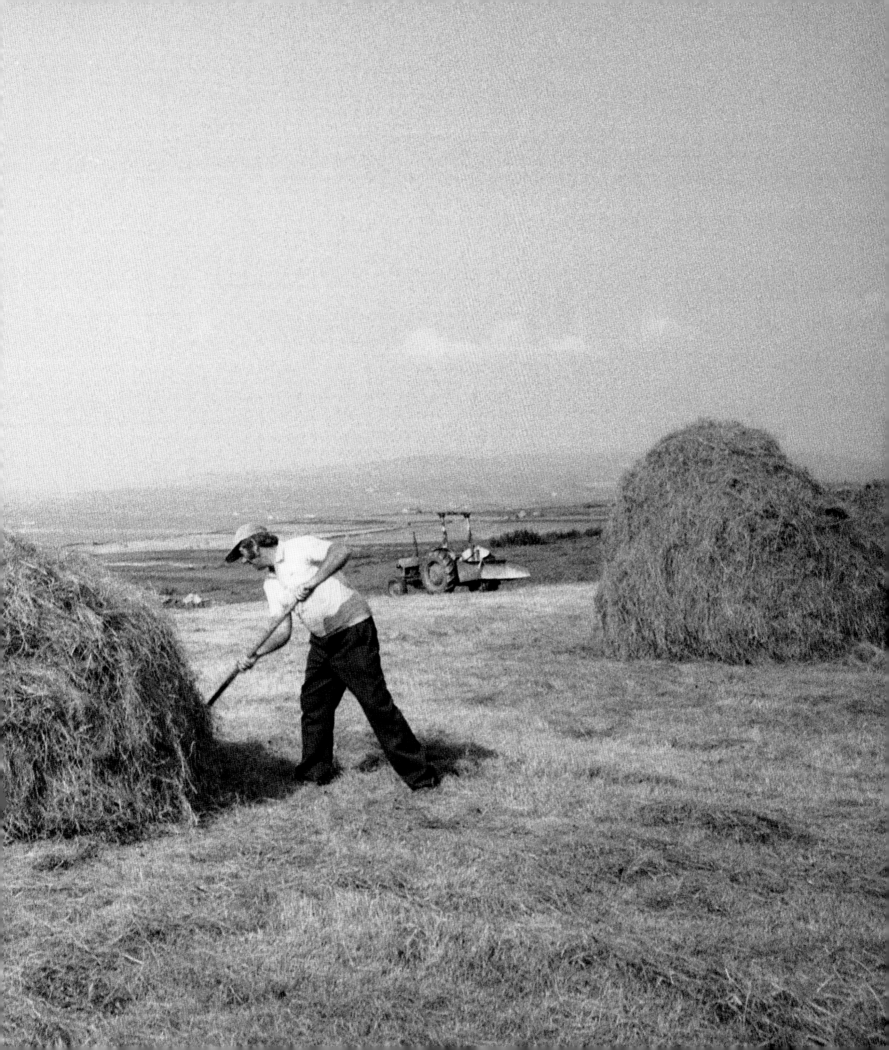

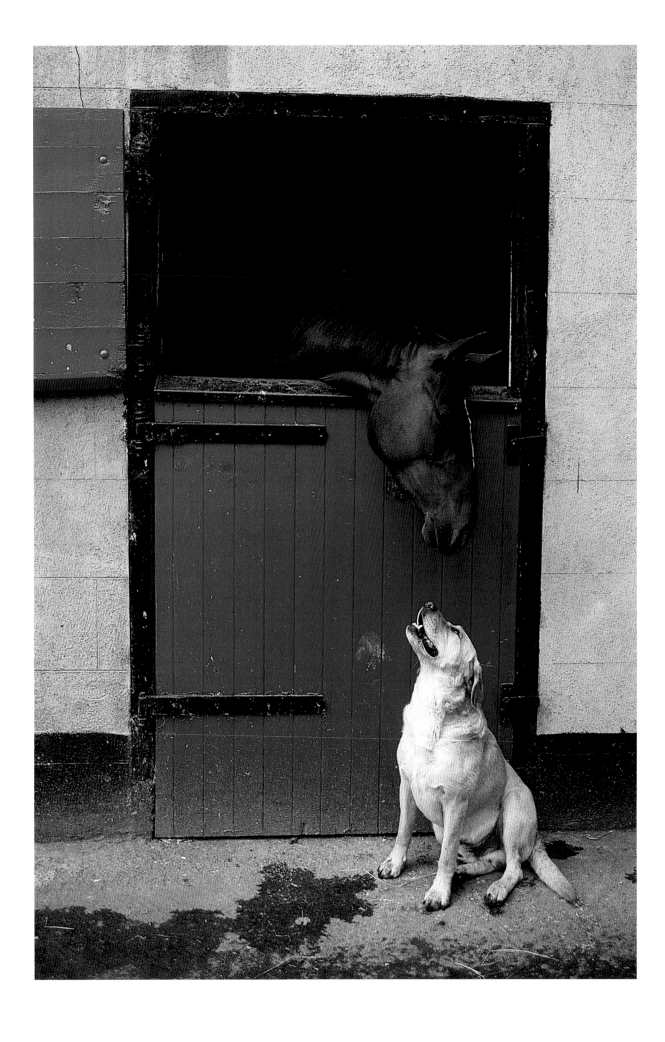

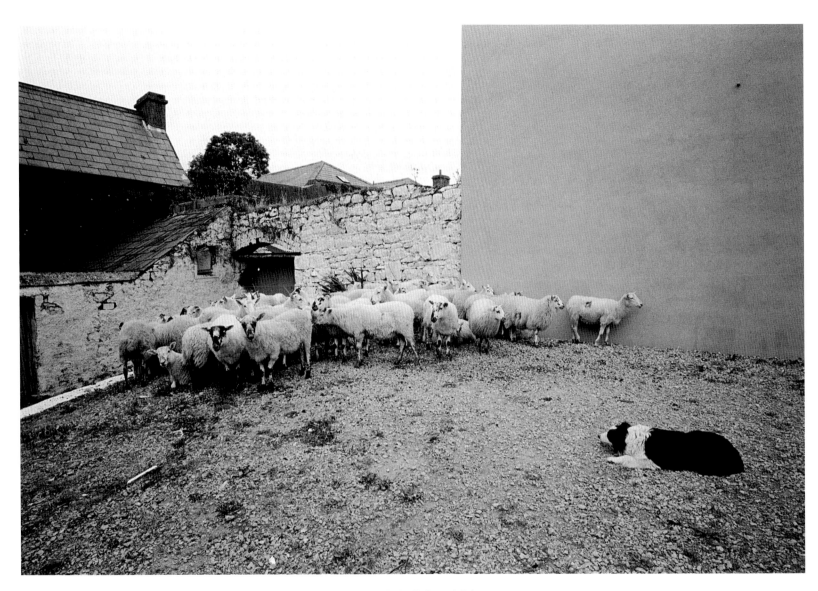

DRUMKEERAN County Leitrim

CASTLETOWN County Kildare

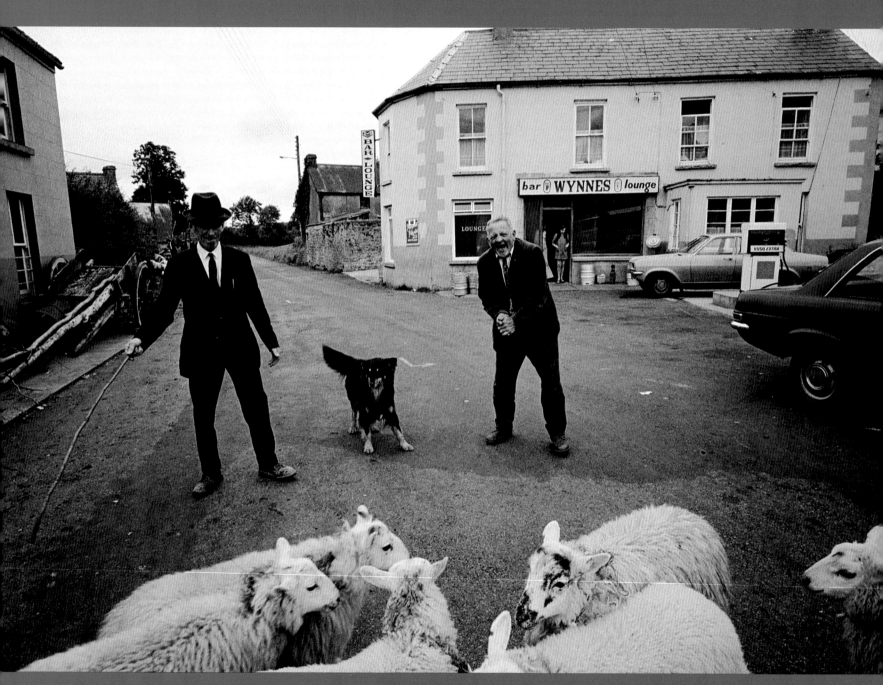

DRUMKEERAN County Leitrim

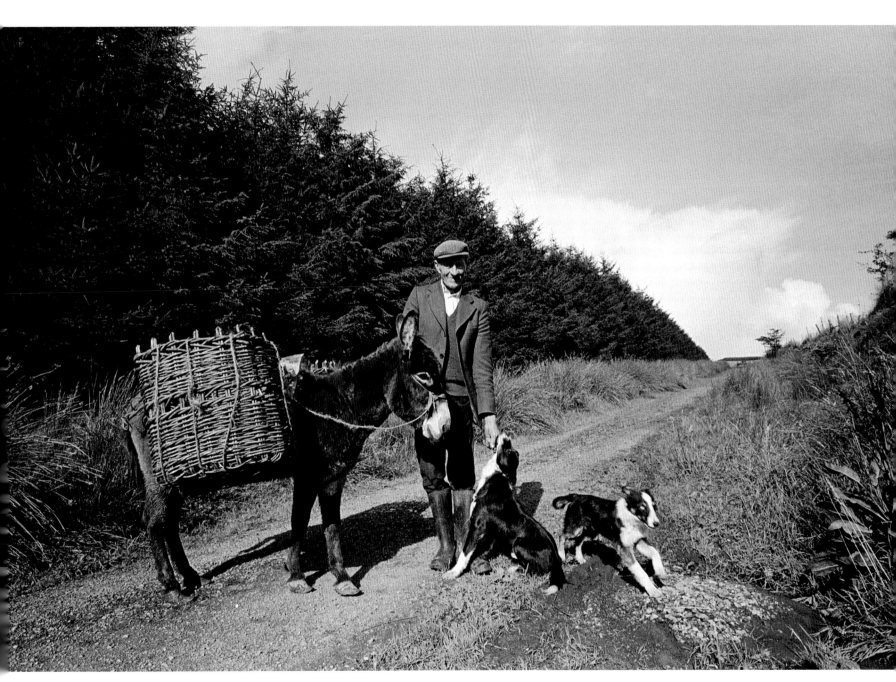

GAEGLUM County Leitrim

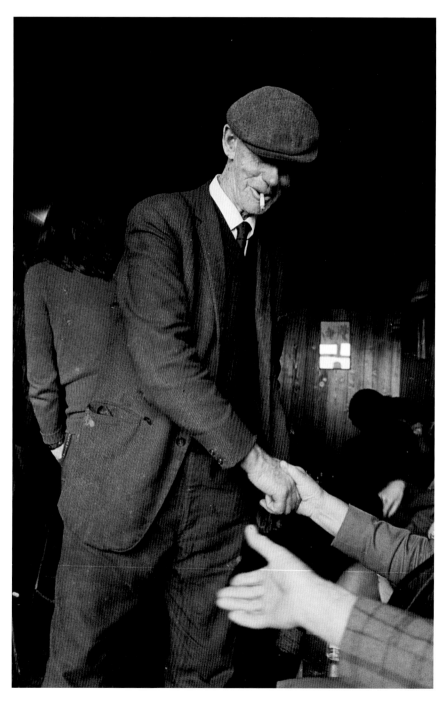

DOWRA County Cavan

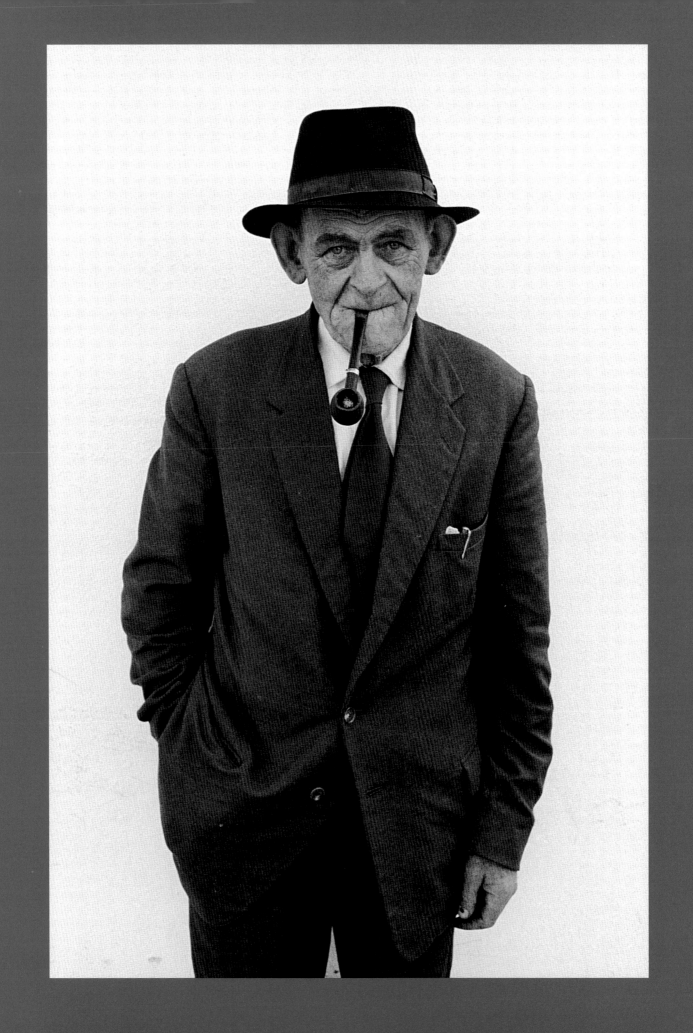

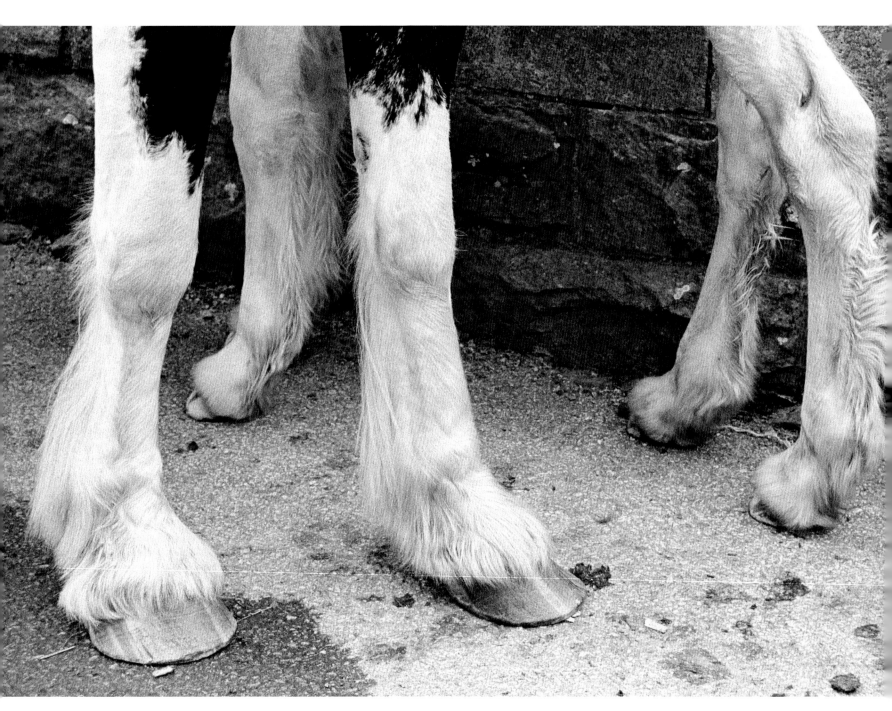

KILLORGLIN County Kerry

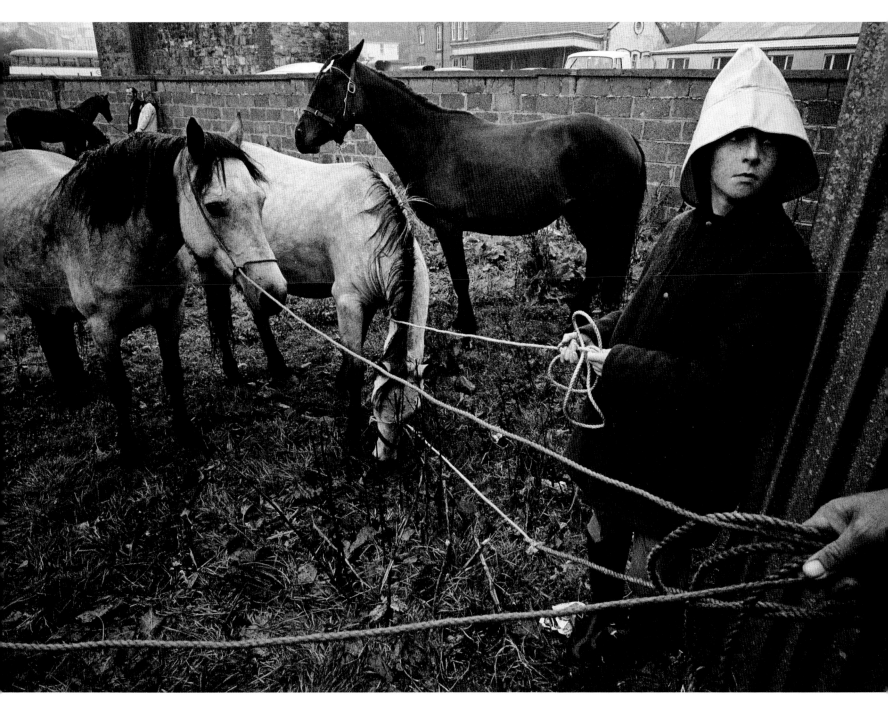

CLIFDEN Connemara

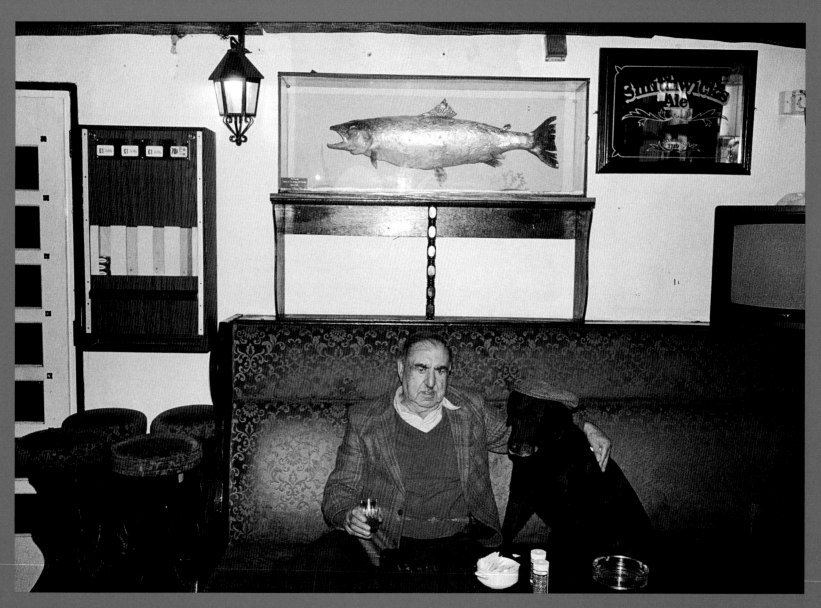

GALWAY CITY County Galway

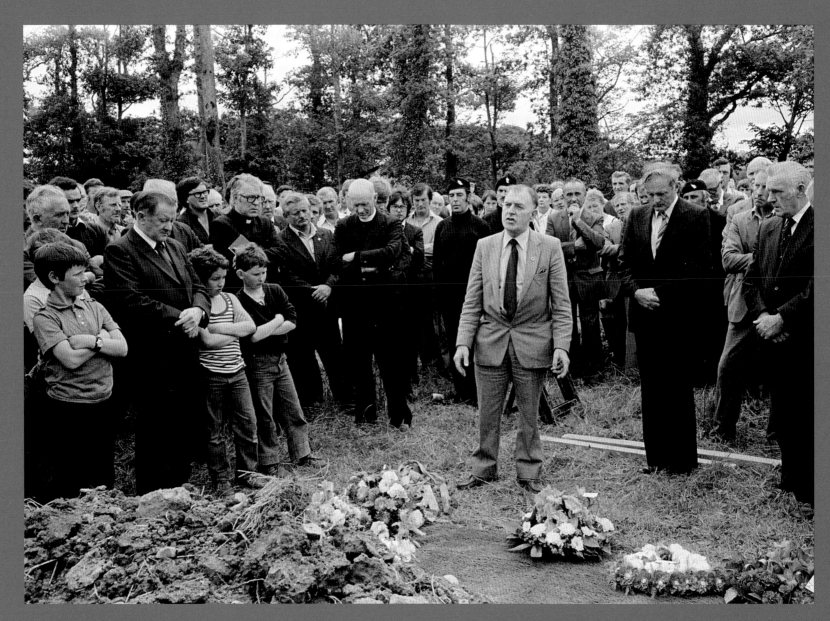

LISTOWEL County Kerry

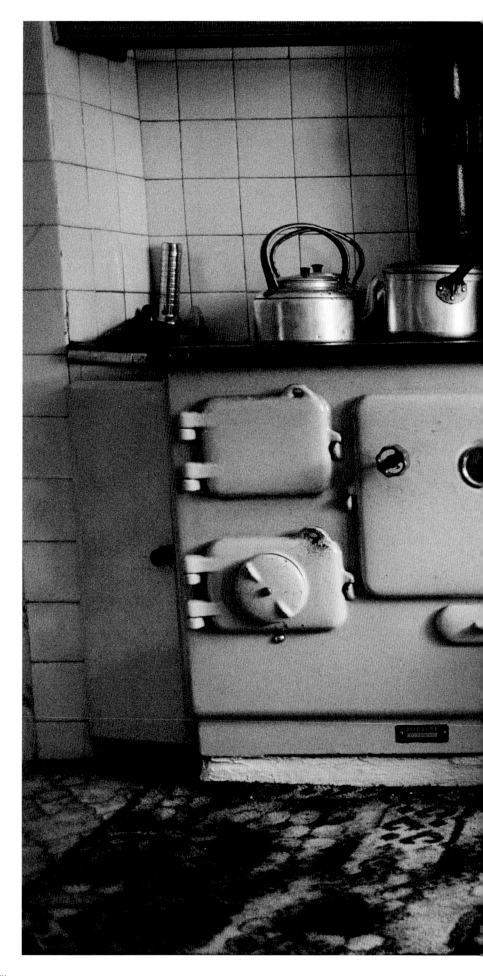

GNIVGUILLA County Kerry

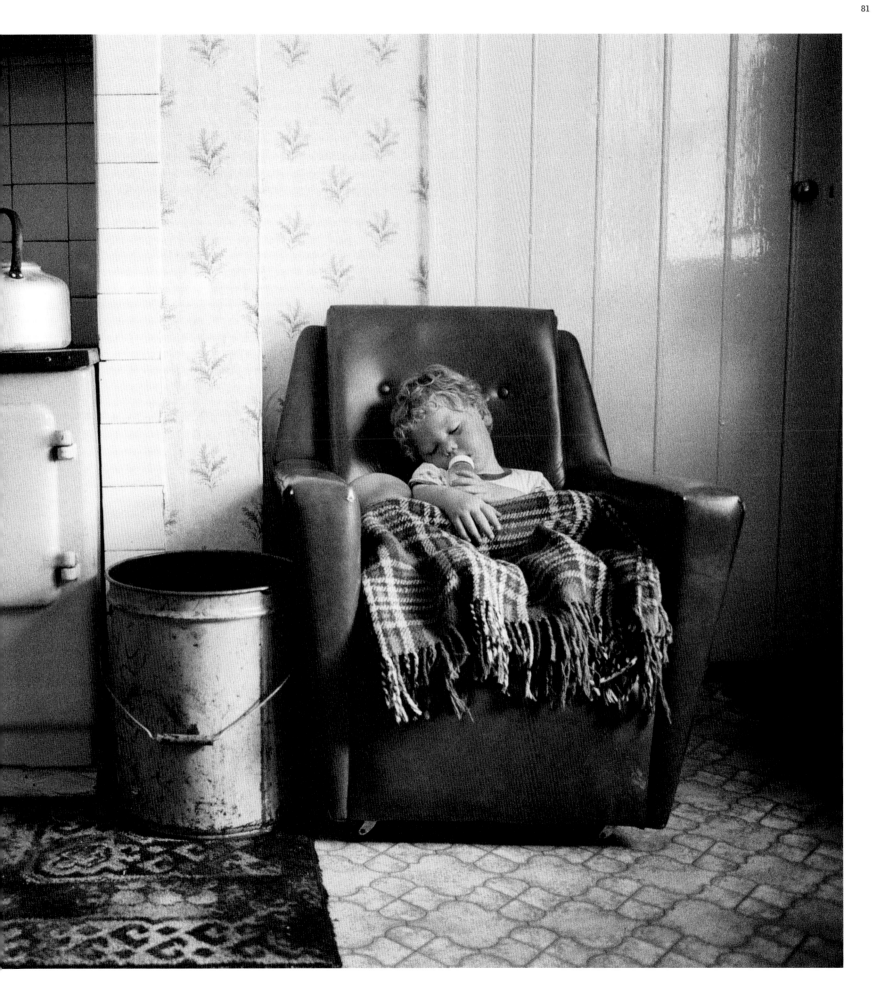

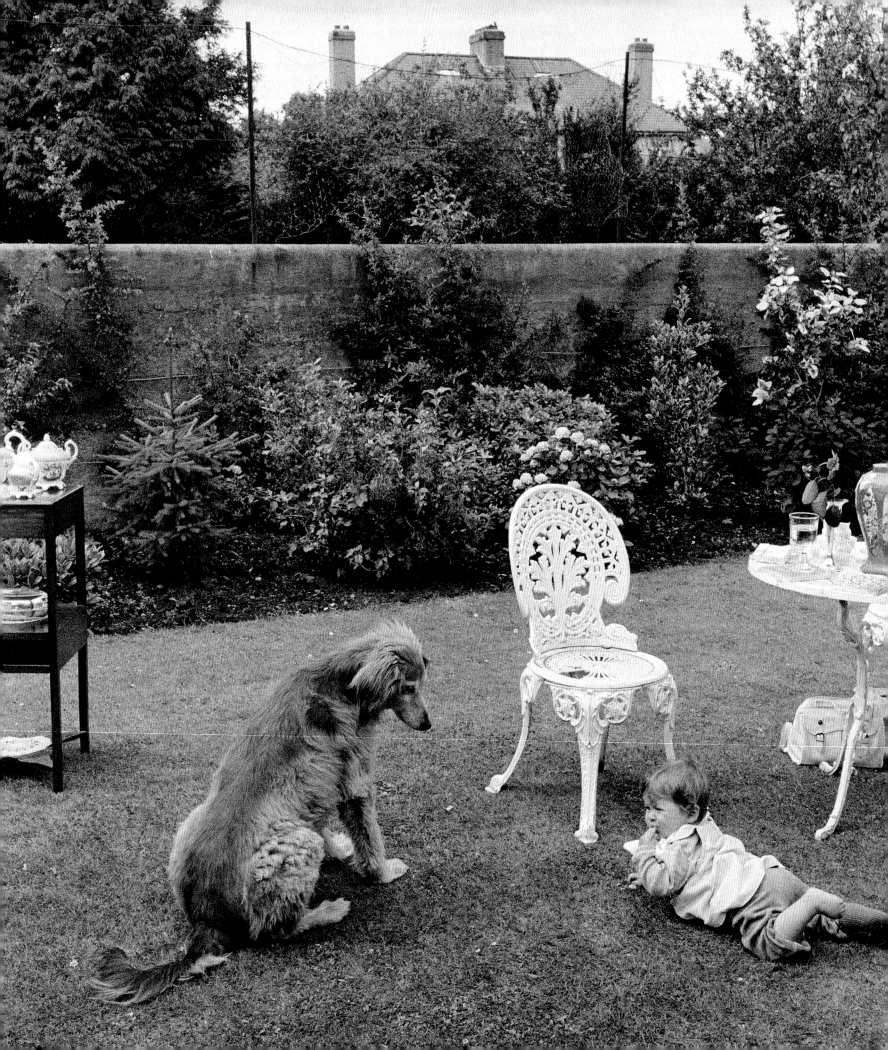

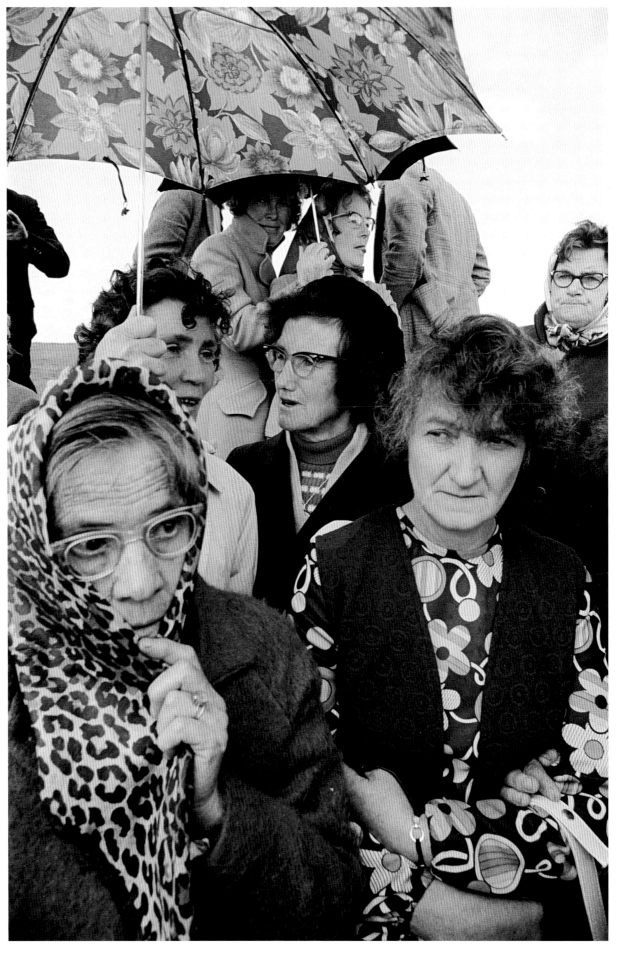

RATHMINES Dublin

GORTEEN County Sligo

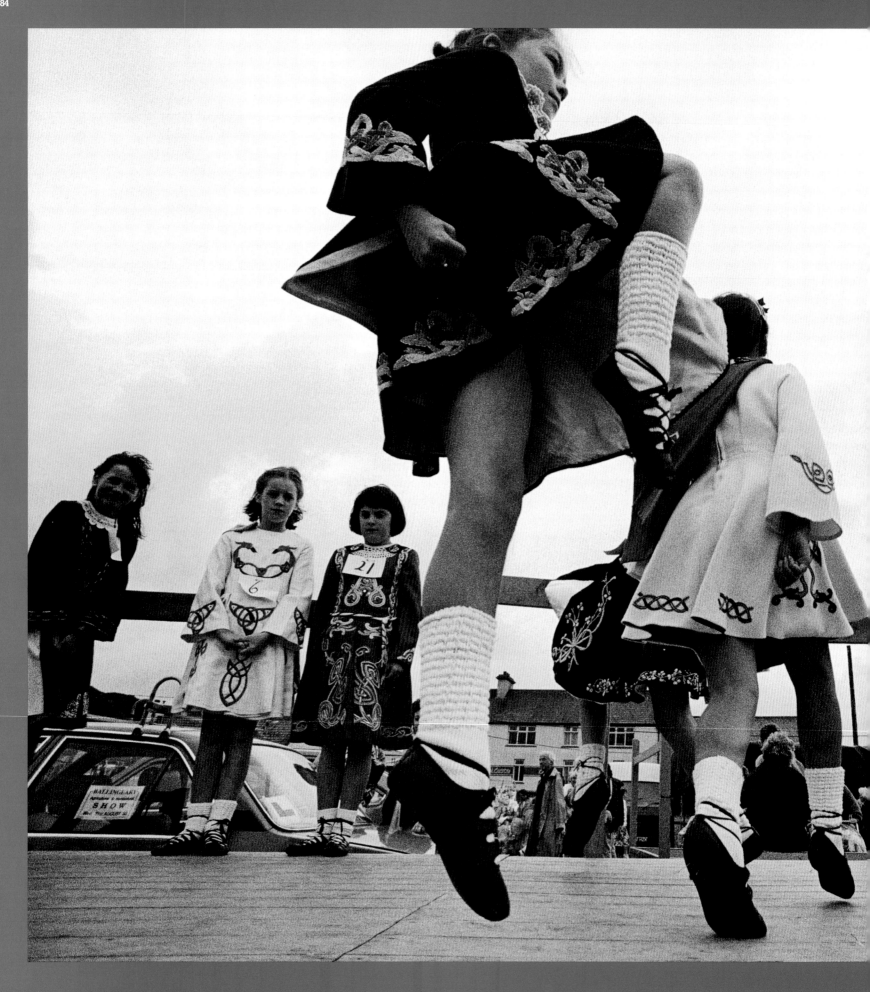

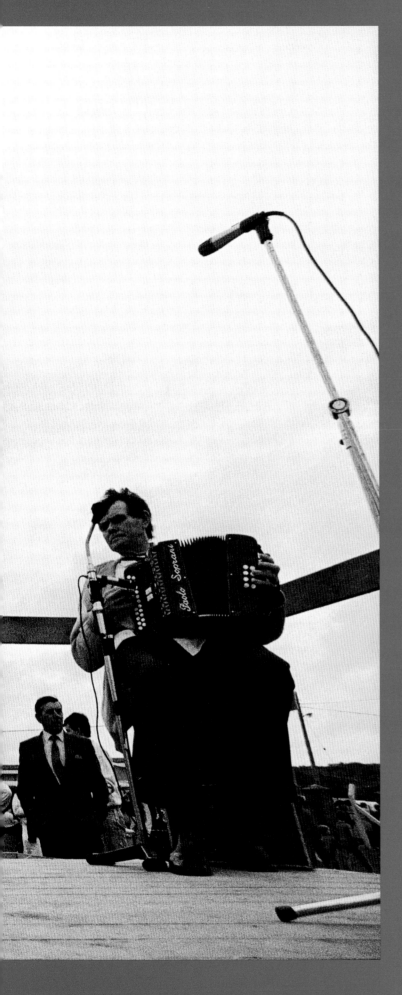

West Cork

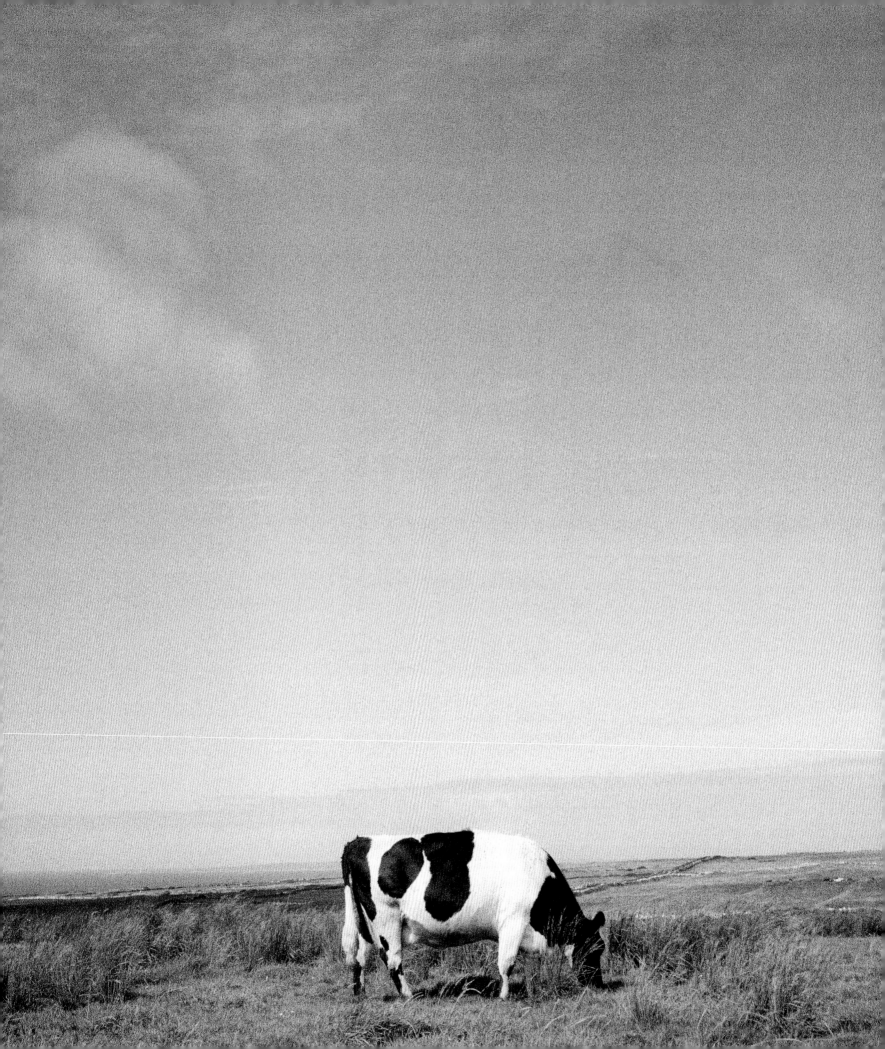

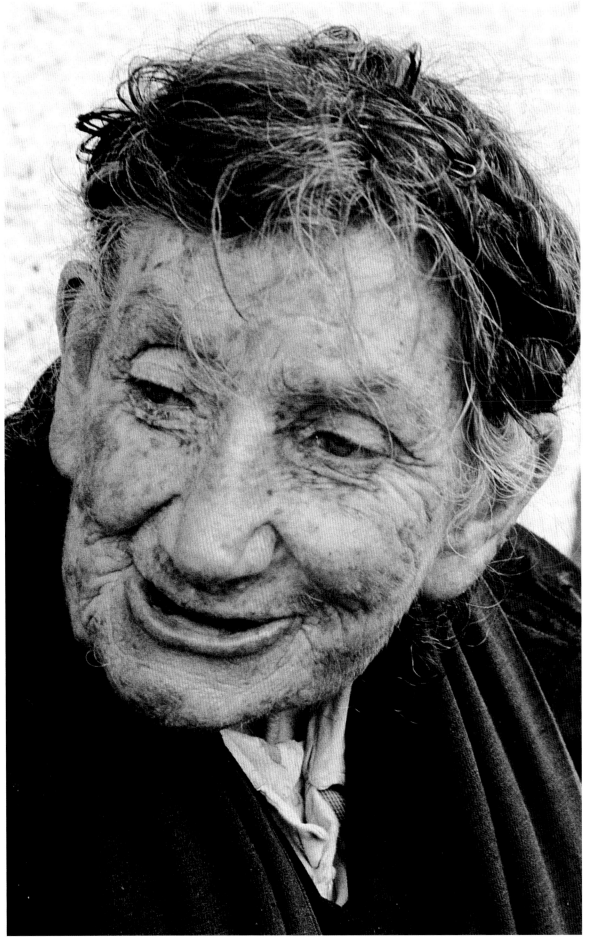

County Kerry

County Tipperary

overleaf: **GORTEEN** County Sligo

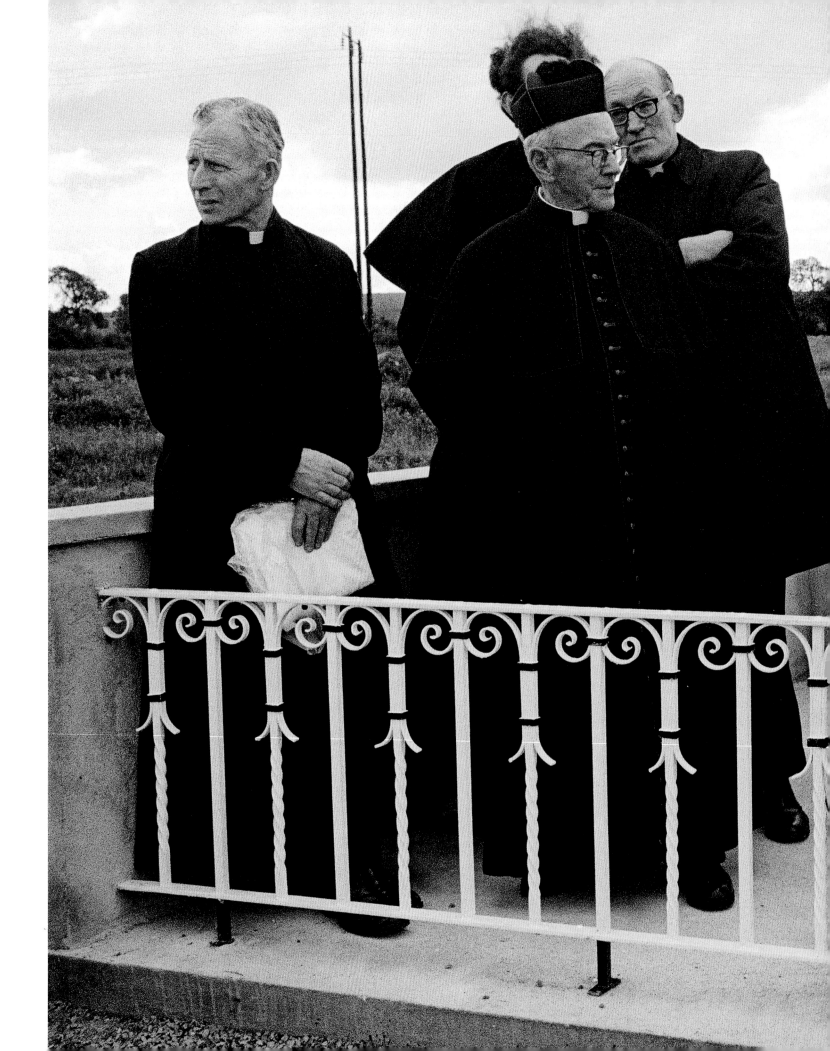

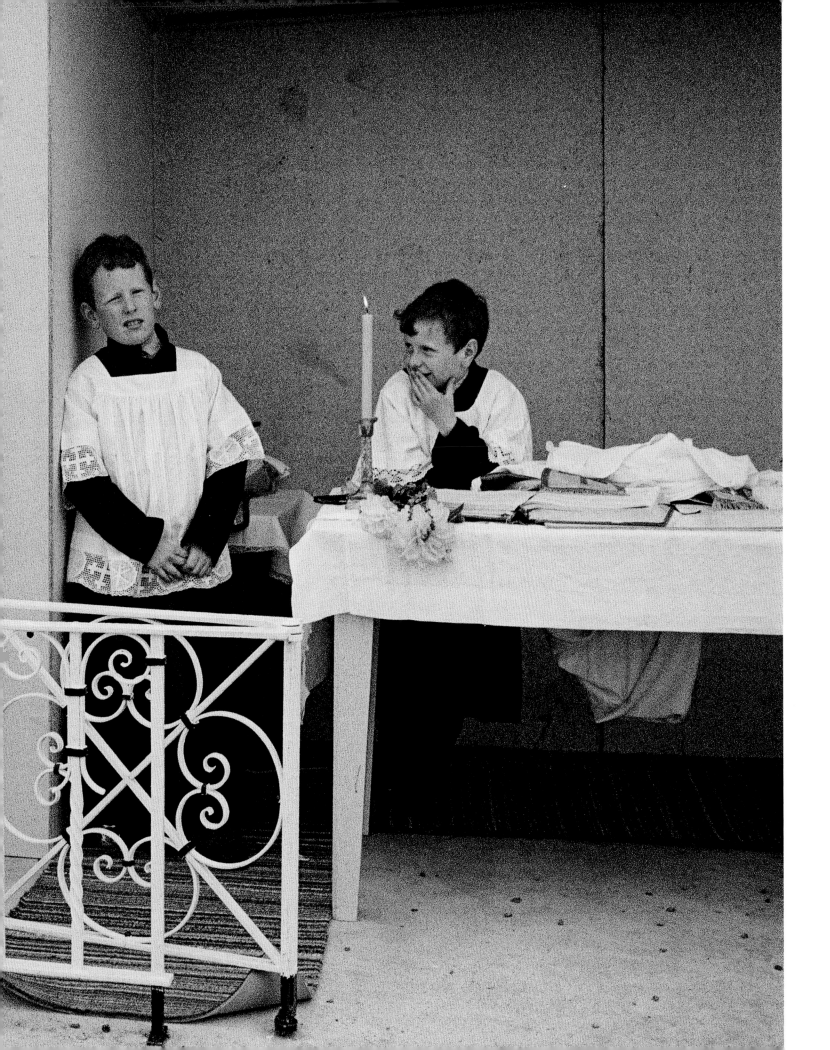

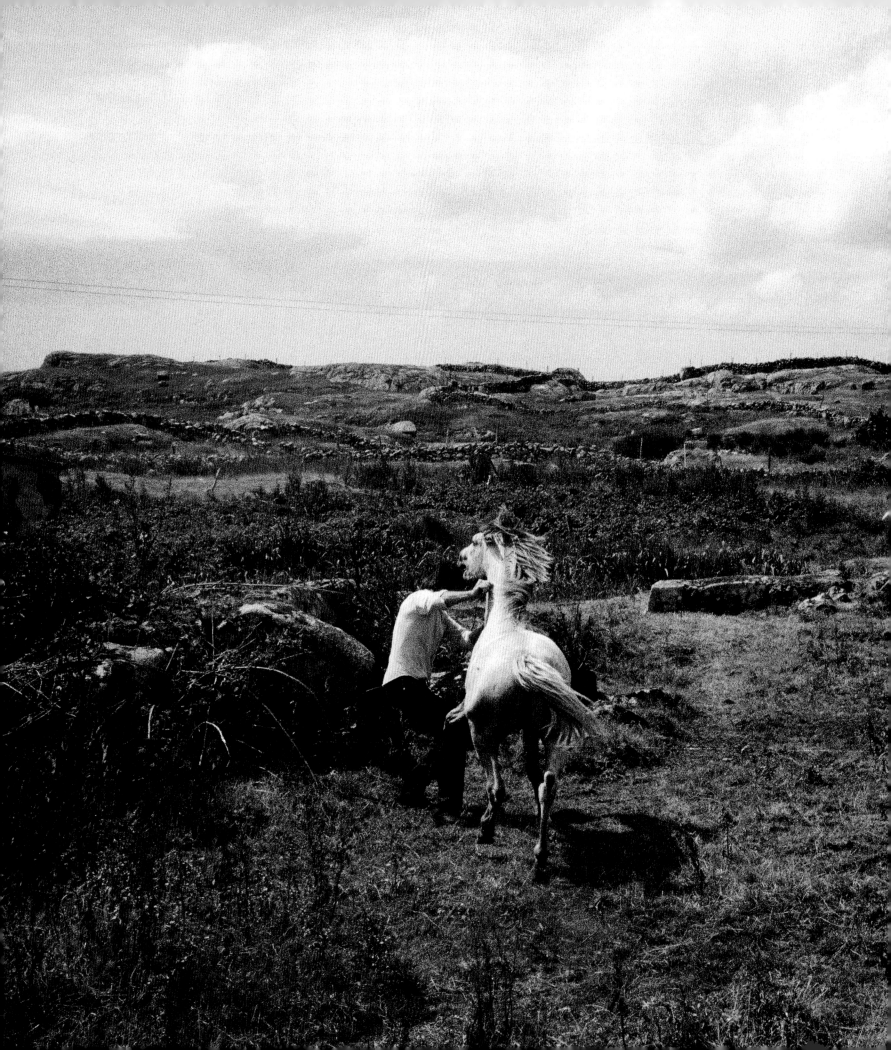

CONNEMARA County Galway

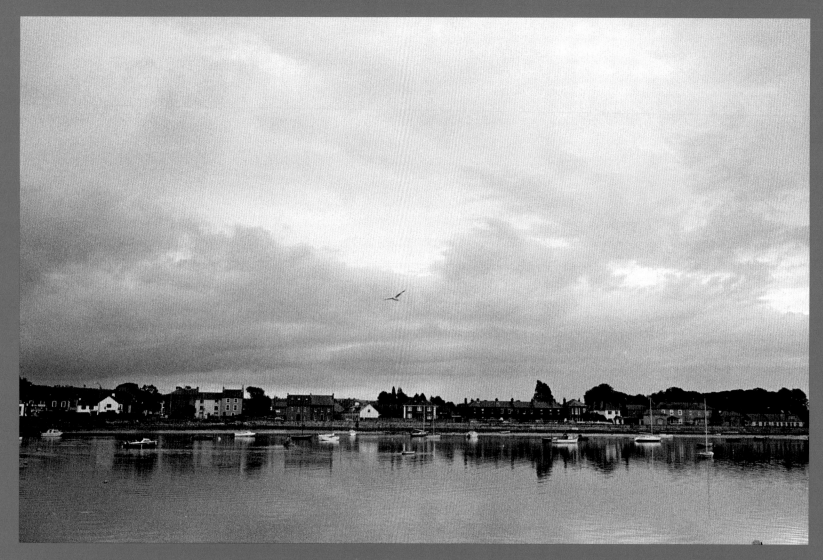

County Donegal

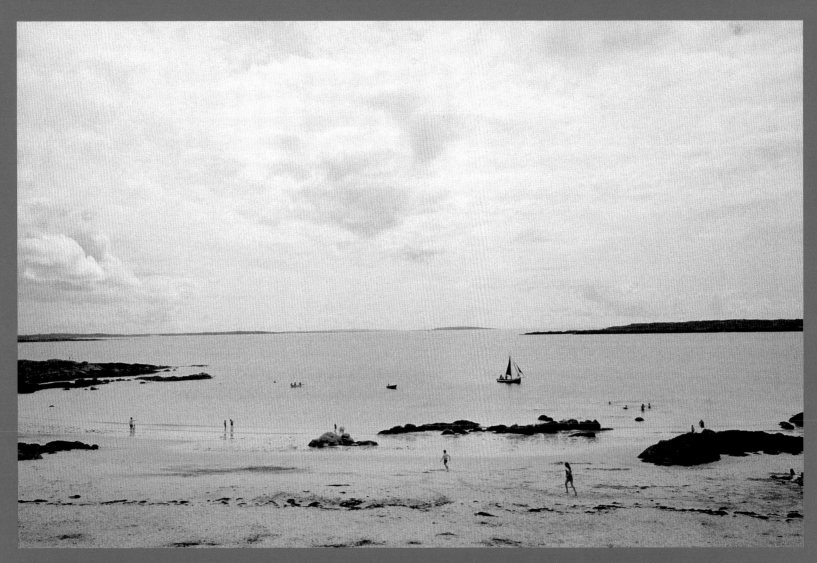

BALLYBUNION County Kerry

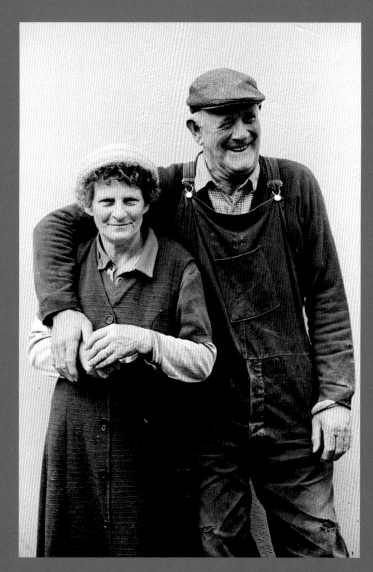

West Cork

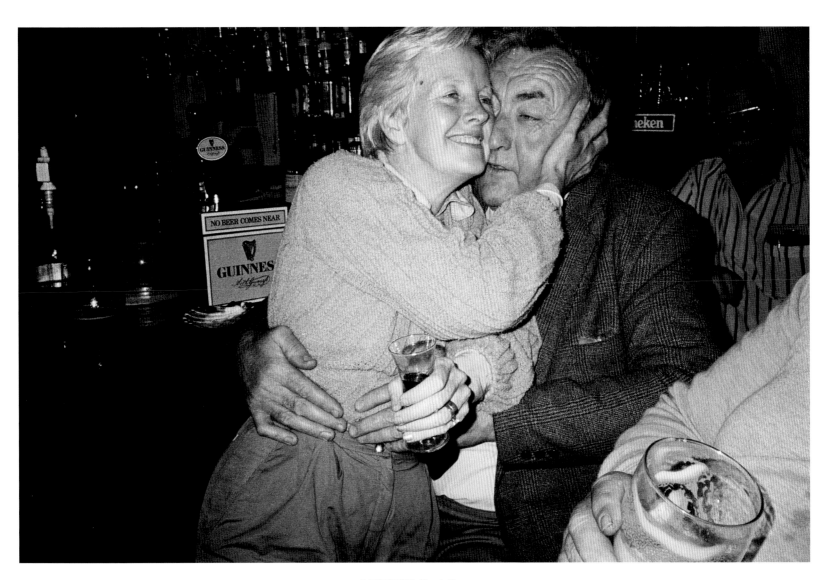

LISTOWEL County Kerry

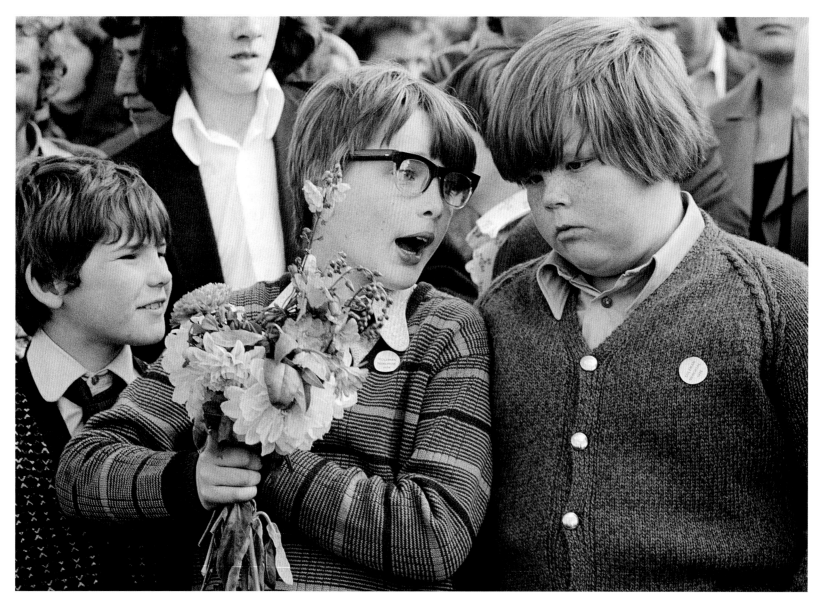

GORTEEN County Sligo

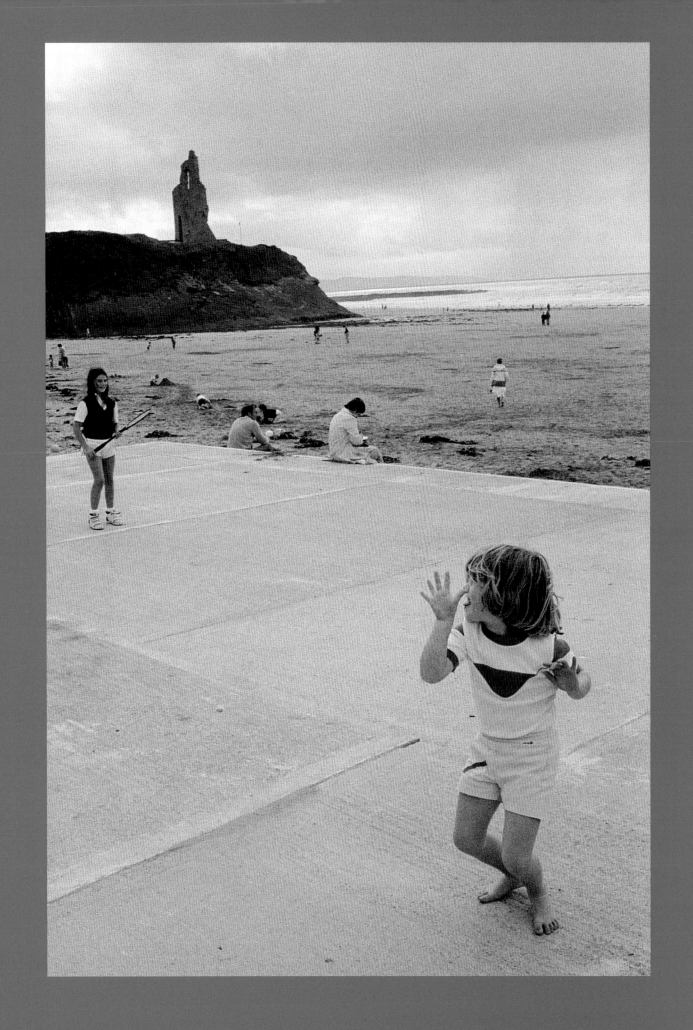

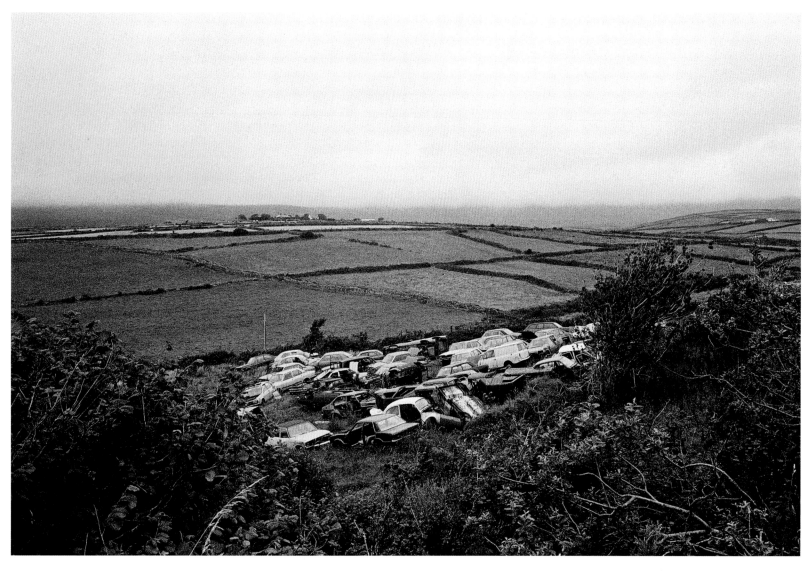

County Kerry

County Clare

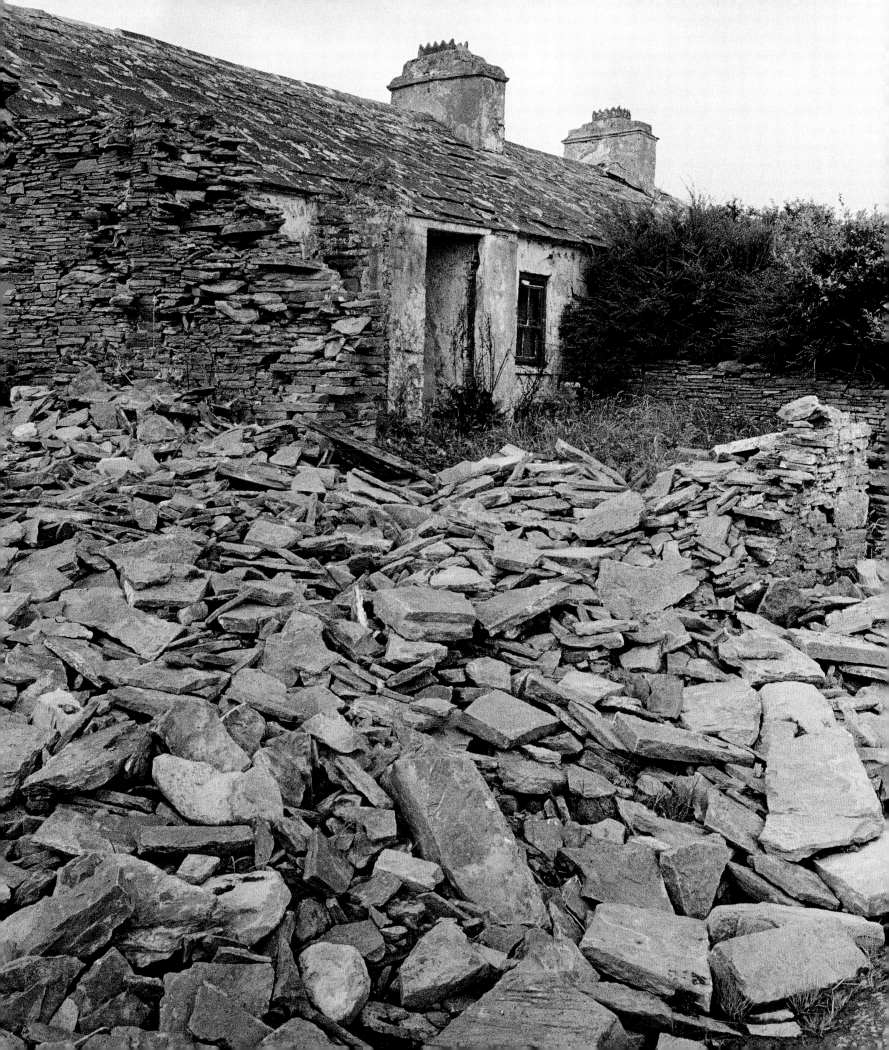

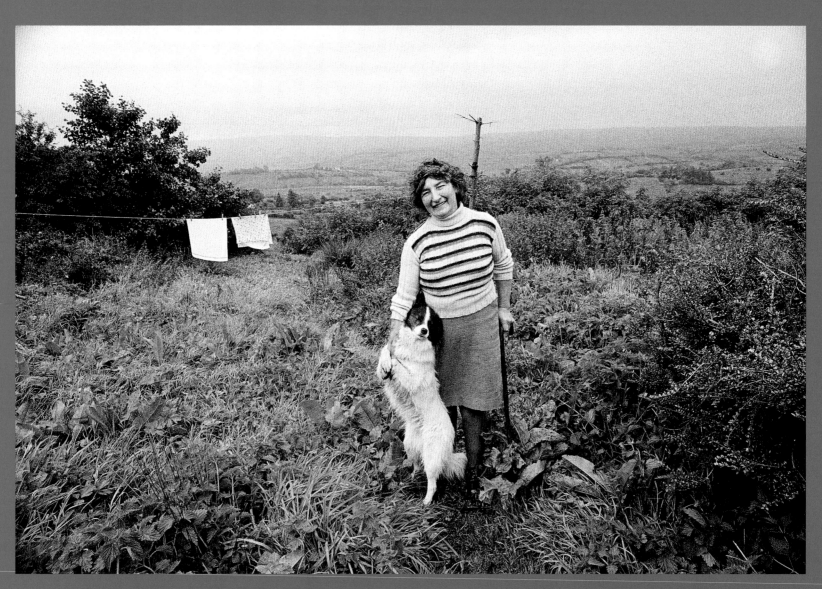

GAEGLUM County Leitrim

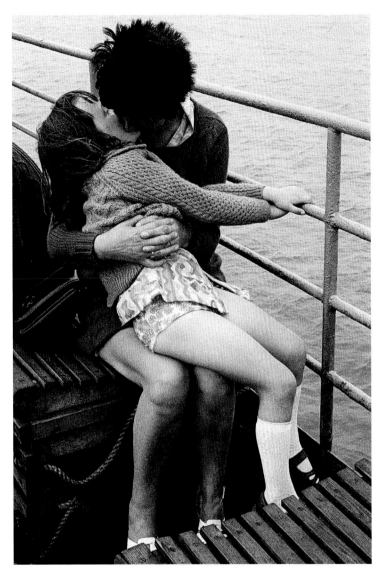

TARBERT FERRY River Shannon

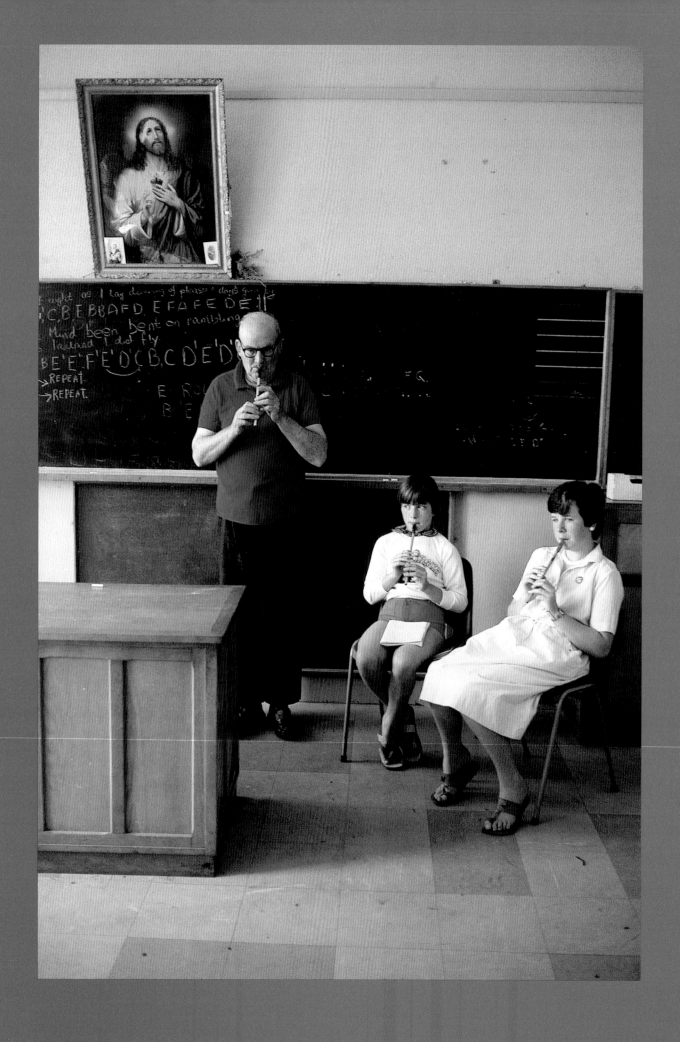

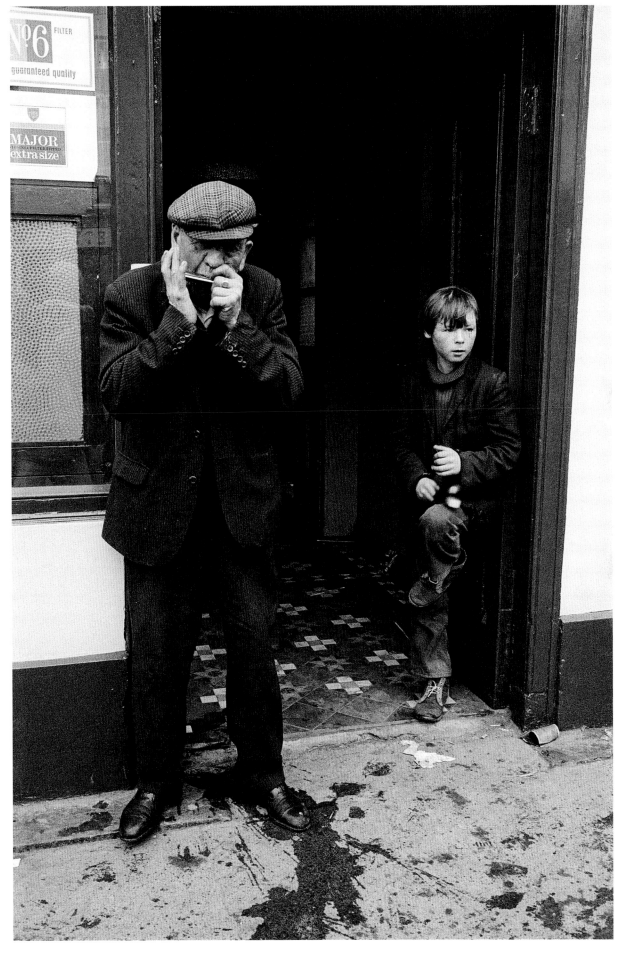

MILLTOWN MALBAY County Clare LISTOWEL County Kerry

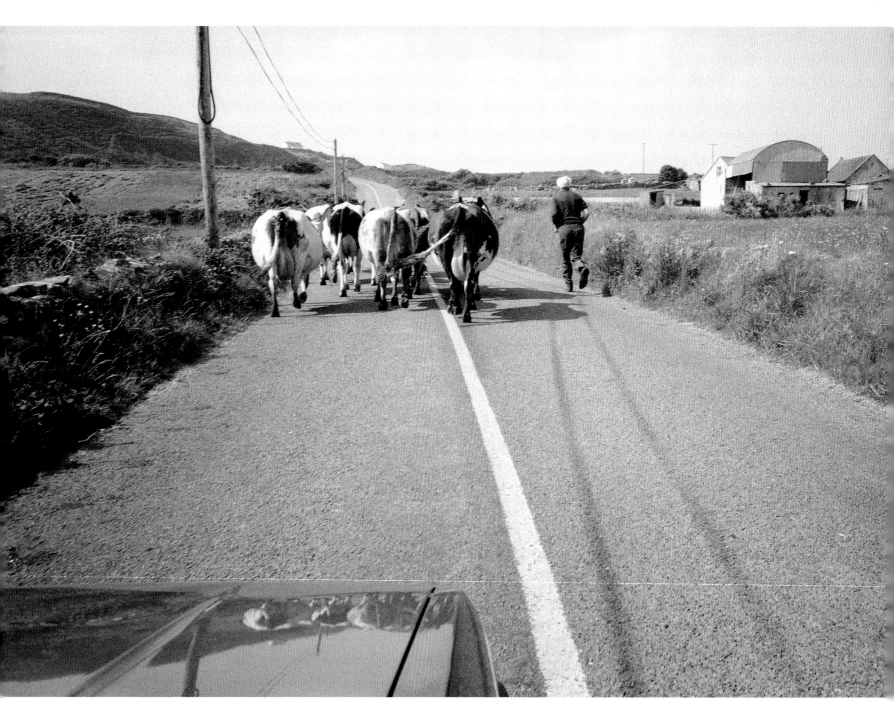

County Clare

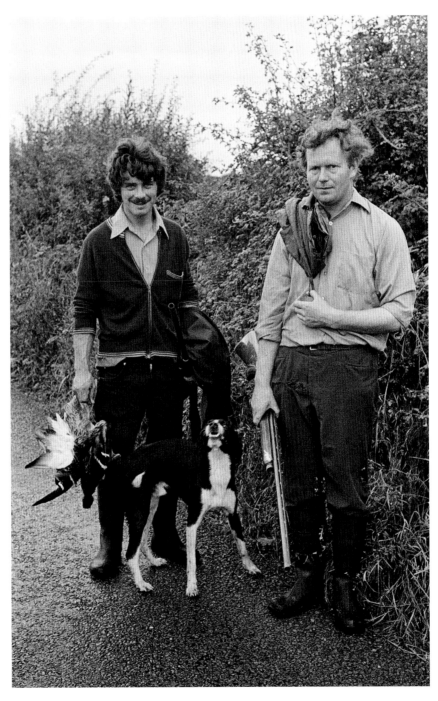

County Clare

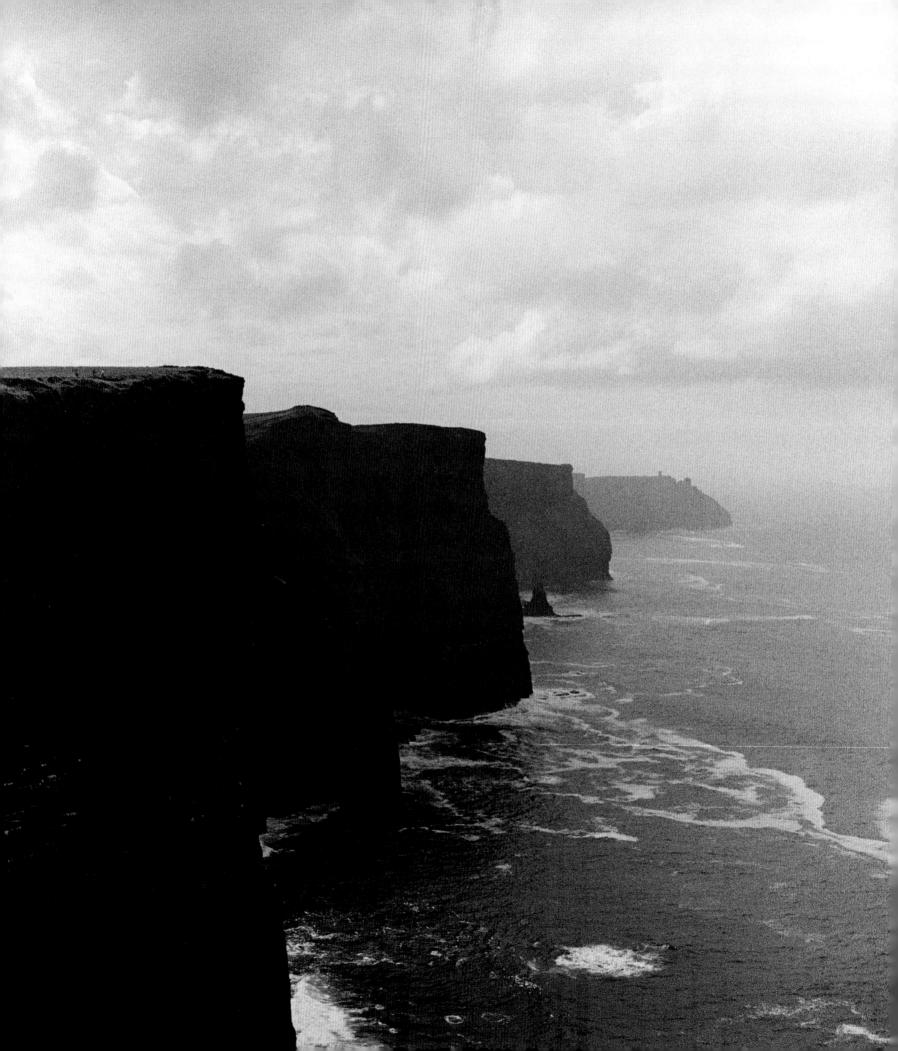

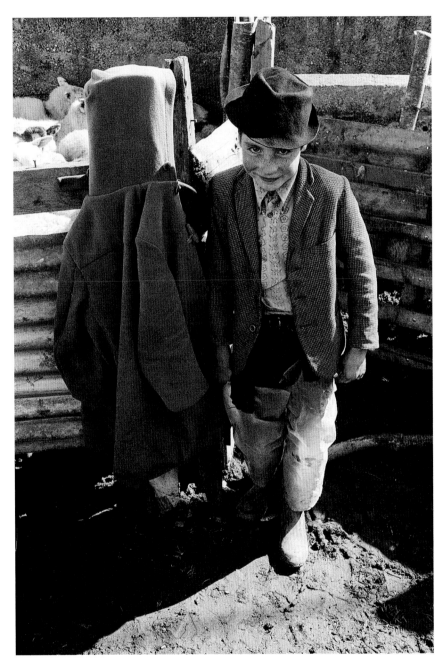

DOWRA County Cavan

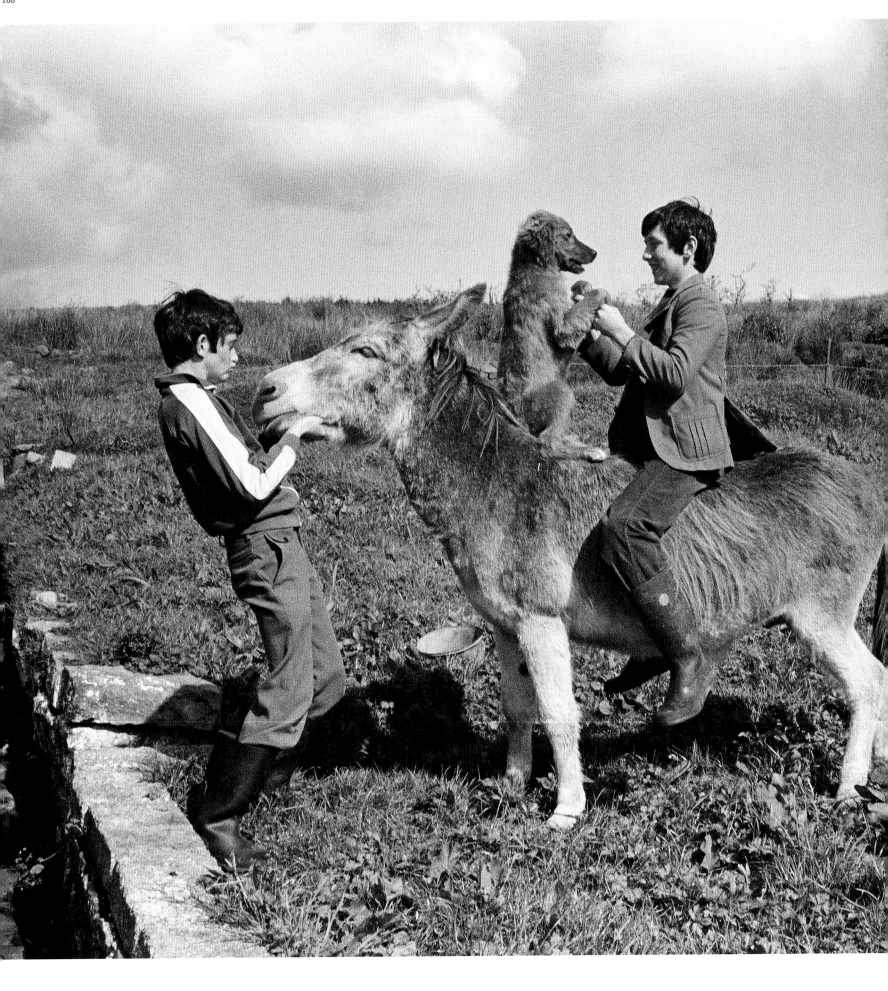

TAWNYLEA County Leitrim

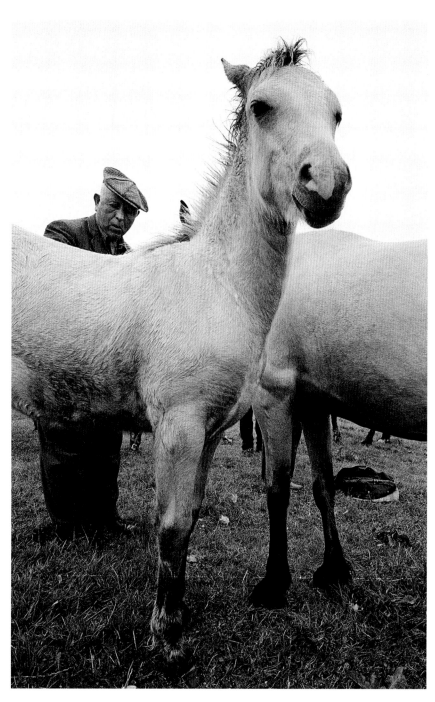

CLIFDEN, CONNEMARA County Galway

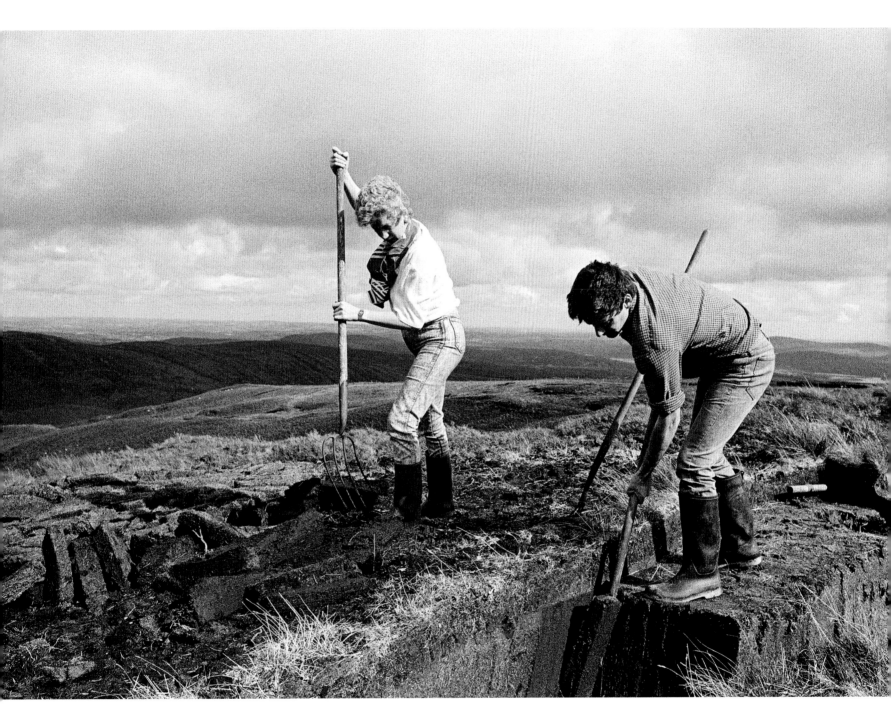

West Cork

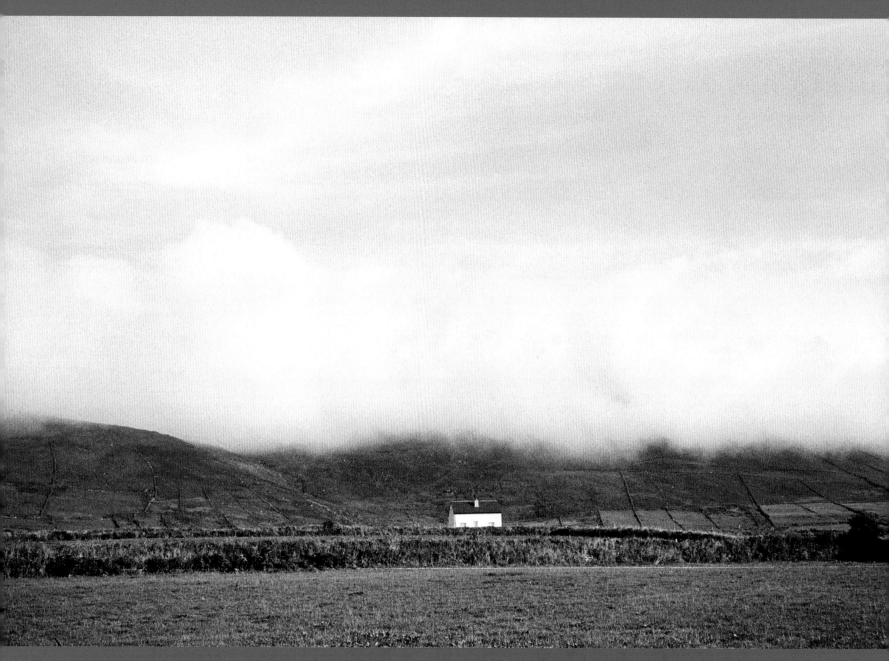

DINGLE County Kerry

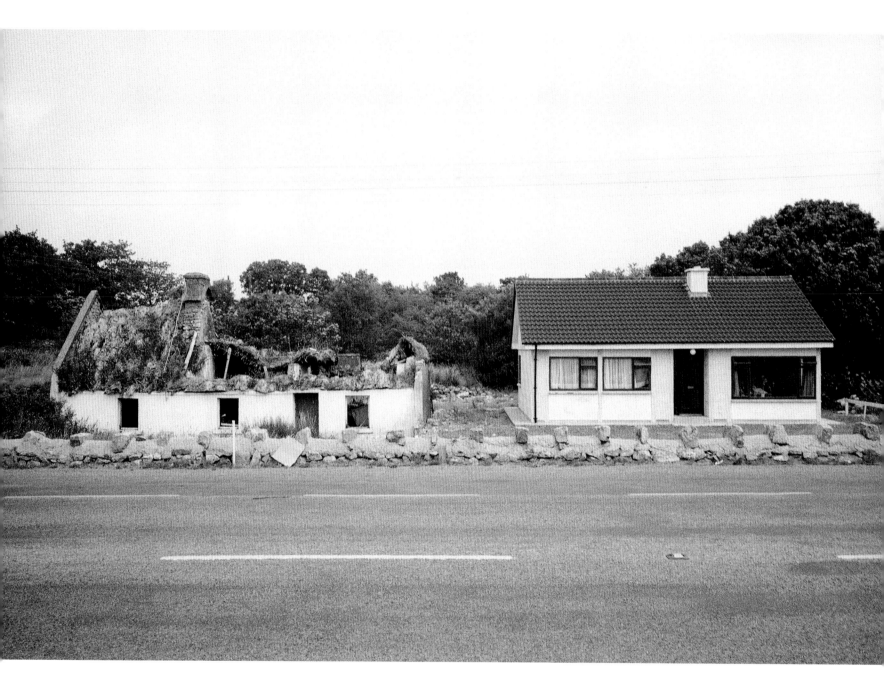

County Galway

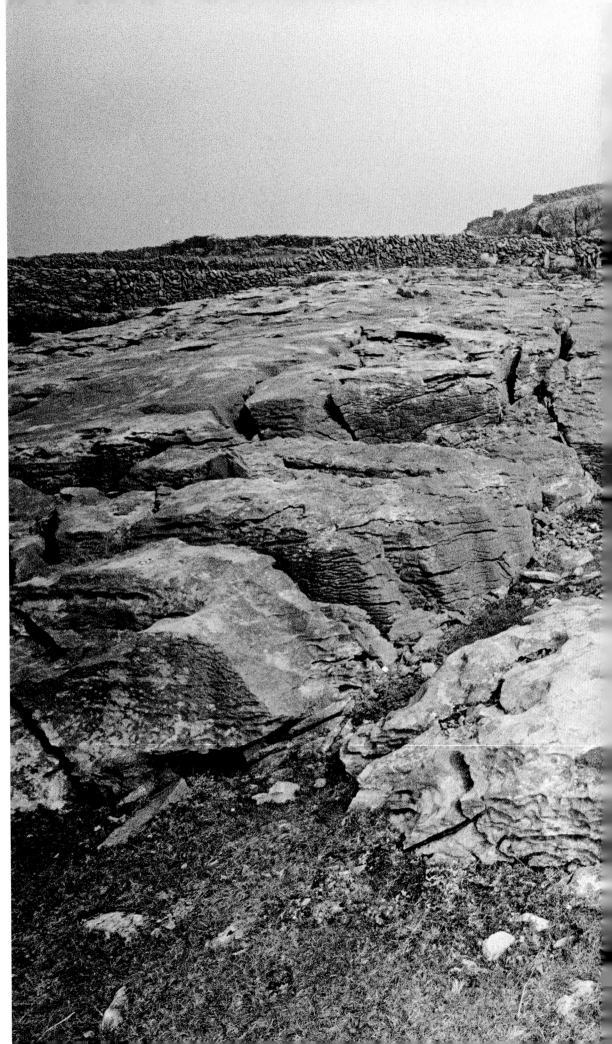

THE BURREN County Clare

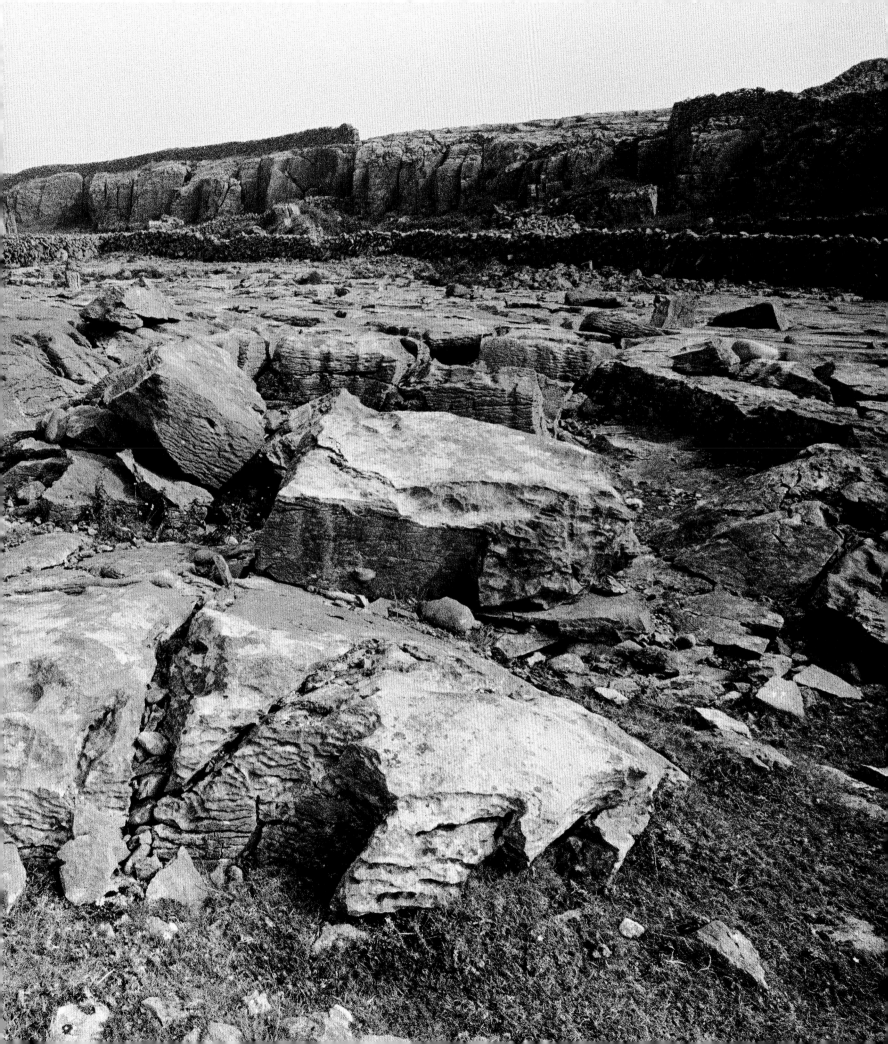

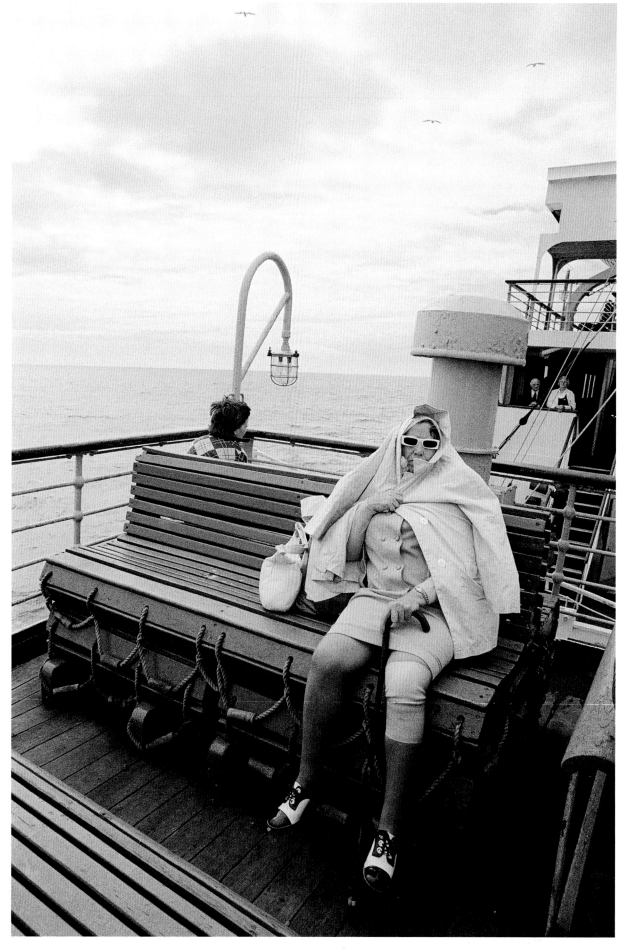

HOLYHEAD FERRY TO DUBLIN

CORK CITY County Cork

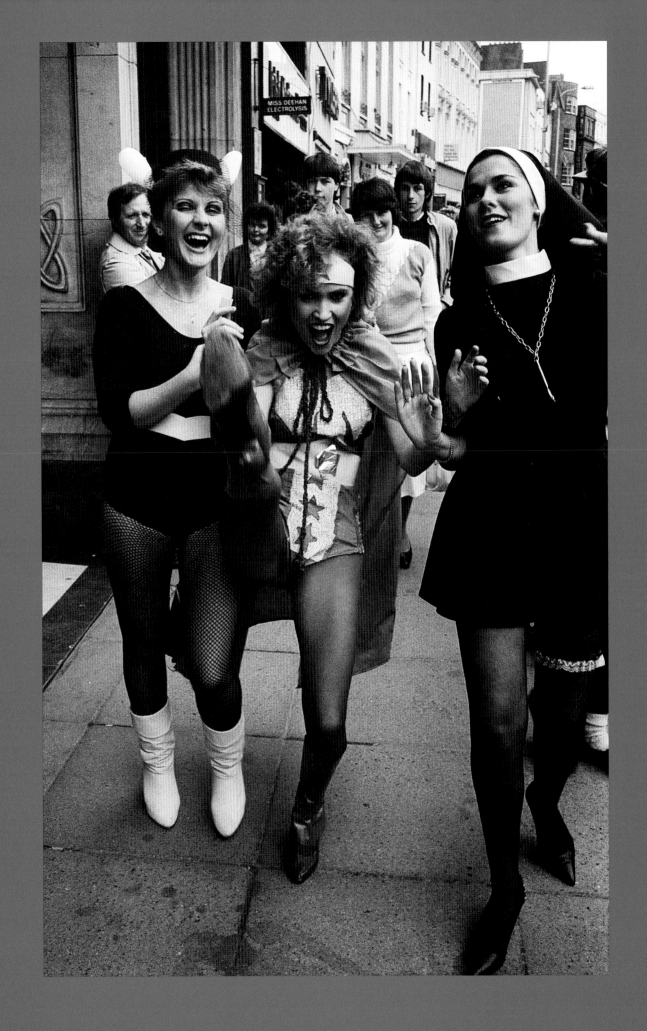

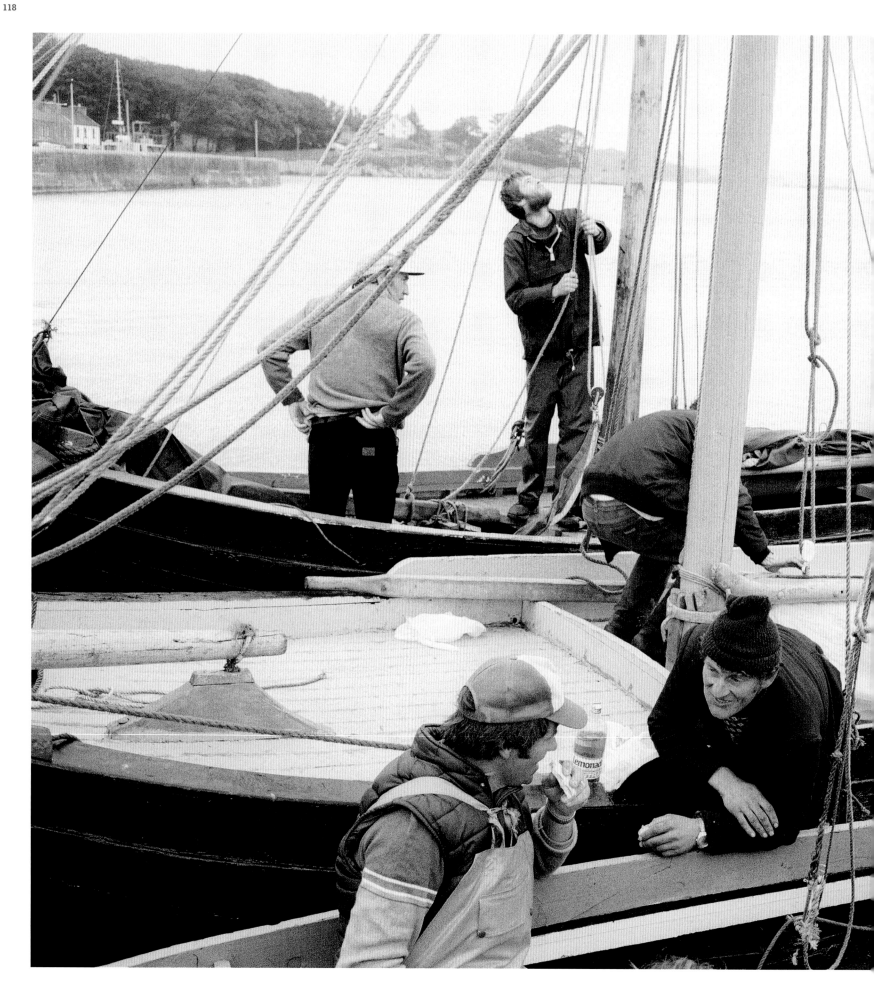

ROUNDSTONE County Galway

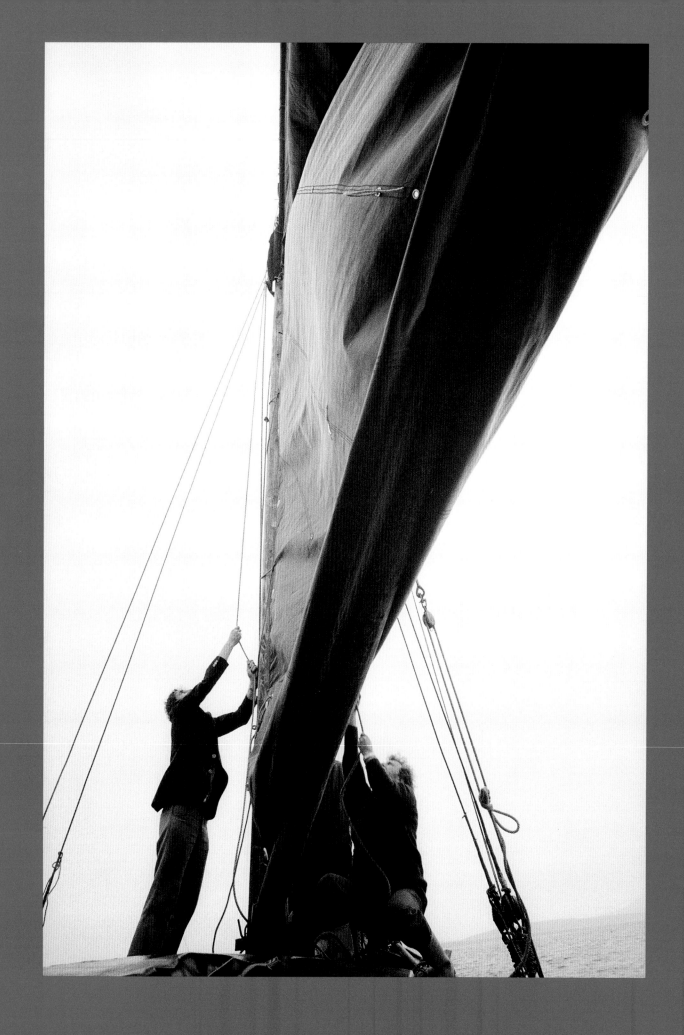

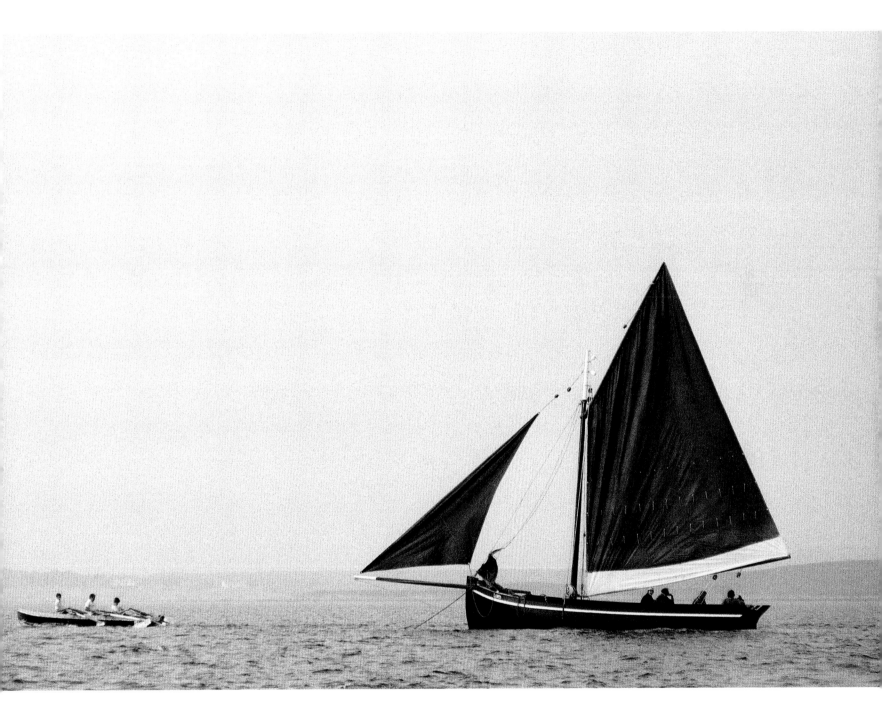

GALWAY BAY County Galway

ROUNDSTONE County Galway

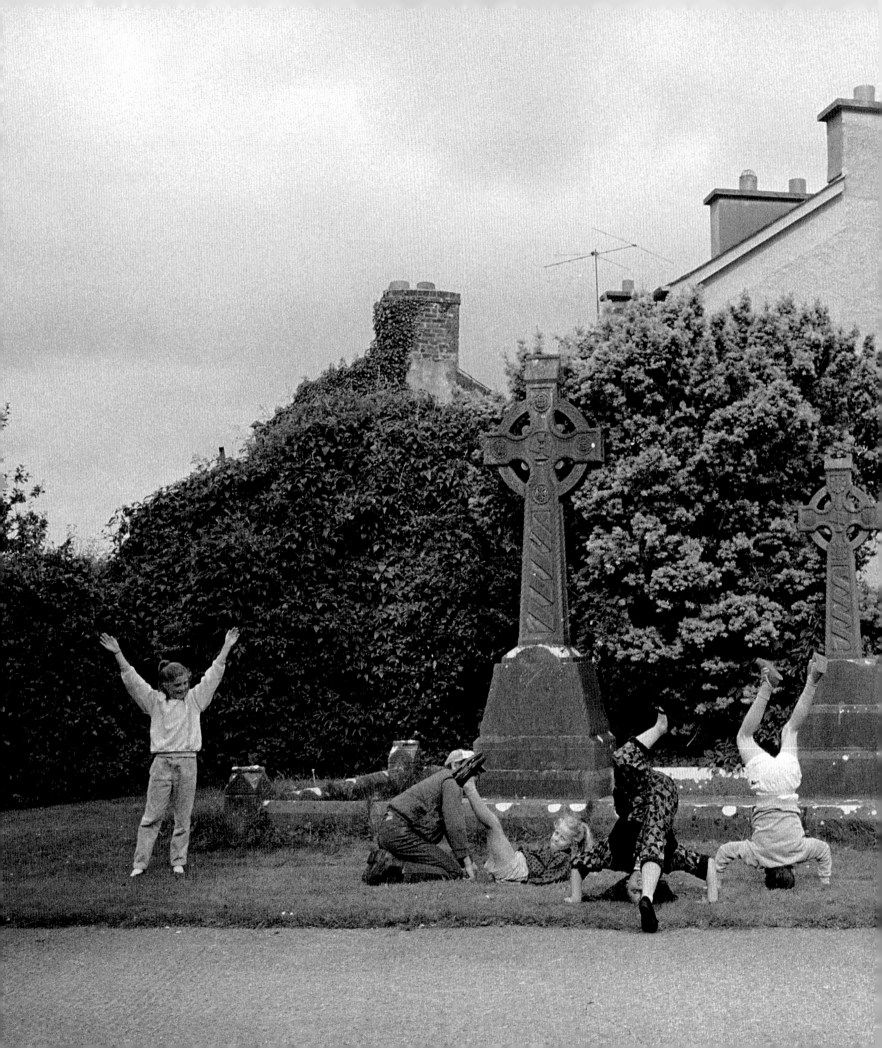

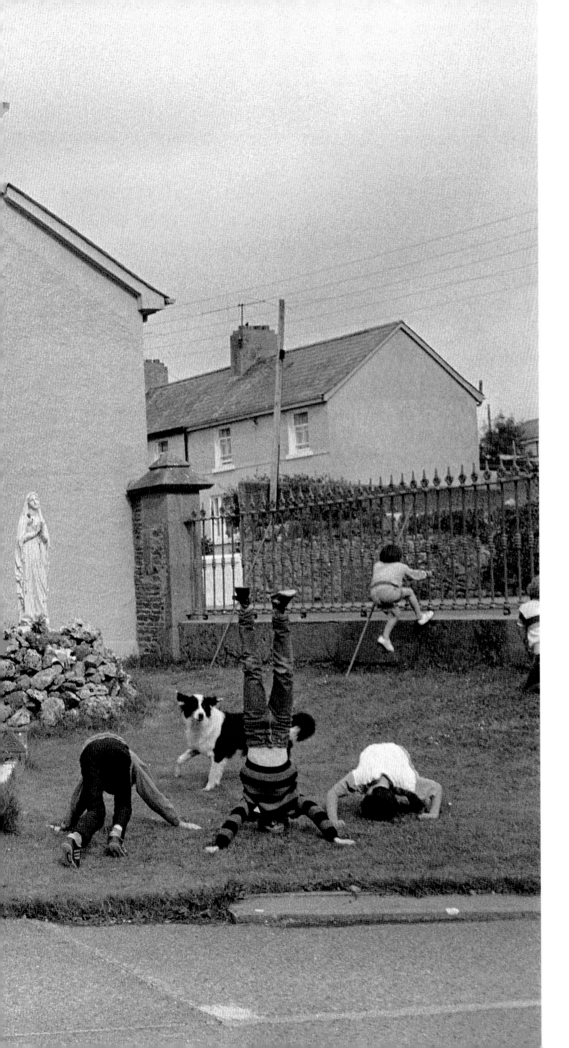

GLIN County Limerick

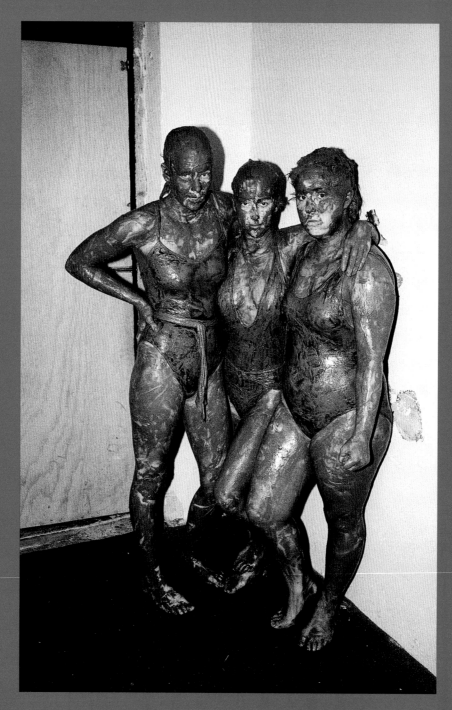

LISTOWEL County Kerry

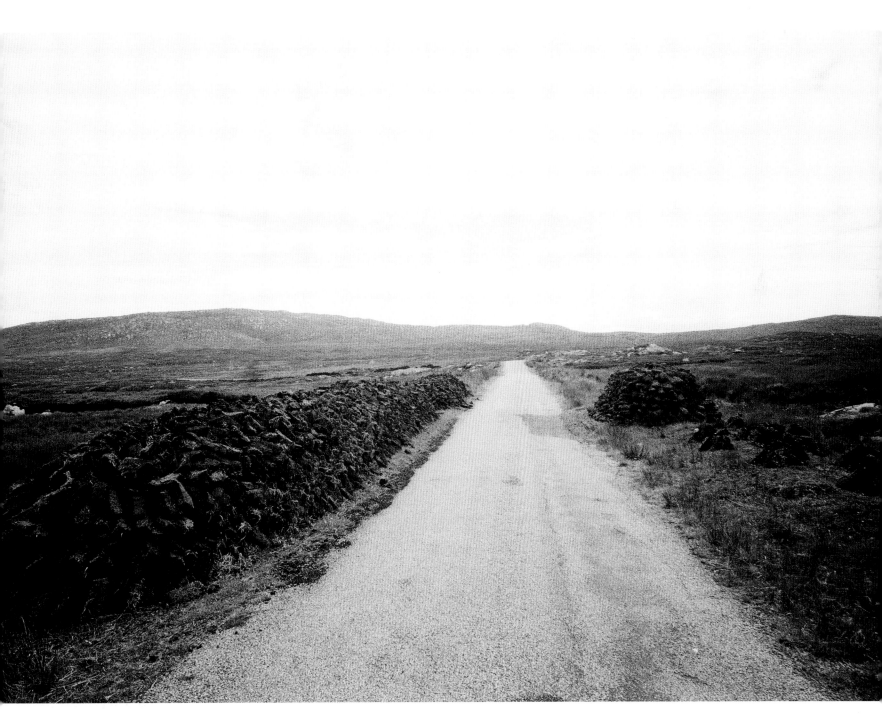

County Galway

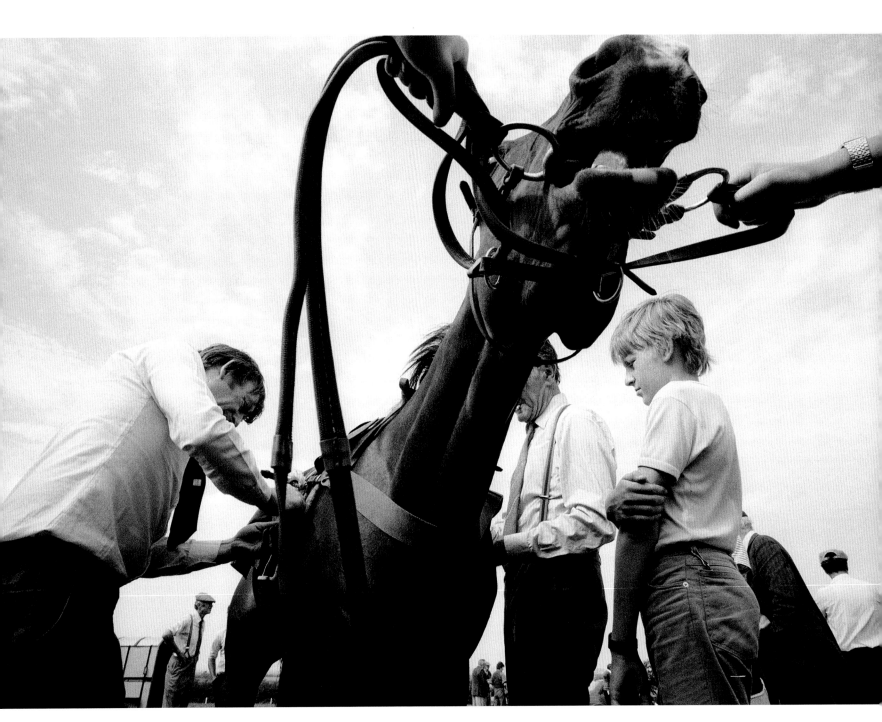

LISTOWEL County Kerry

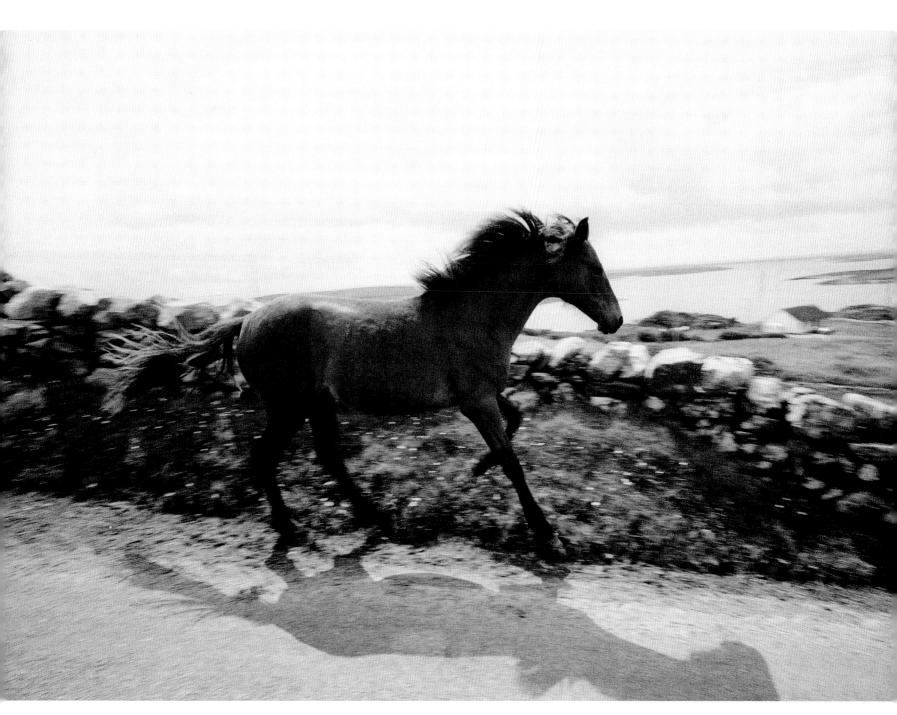

CONNEMARA County Galway

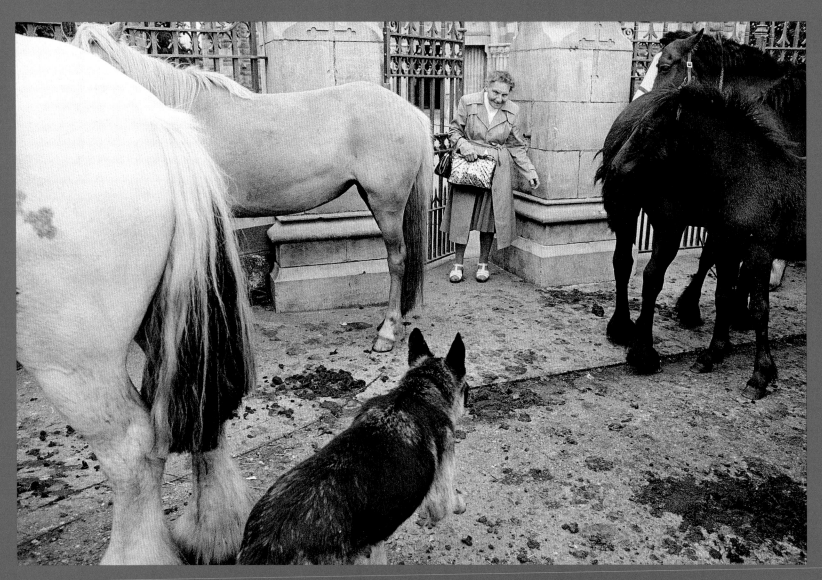

KILLORGLIN County Kerry

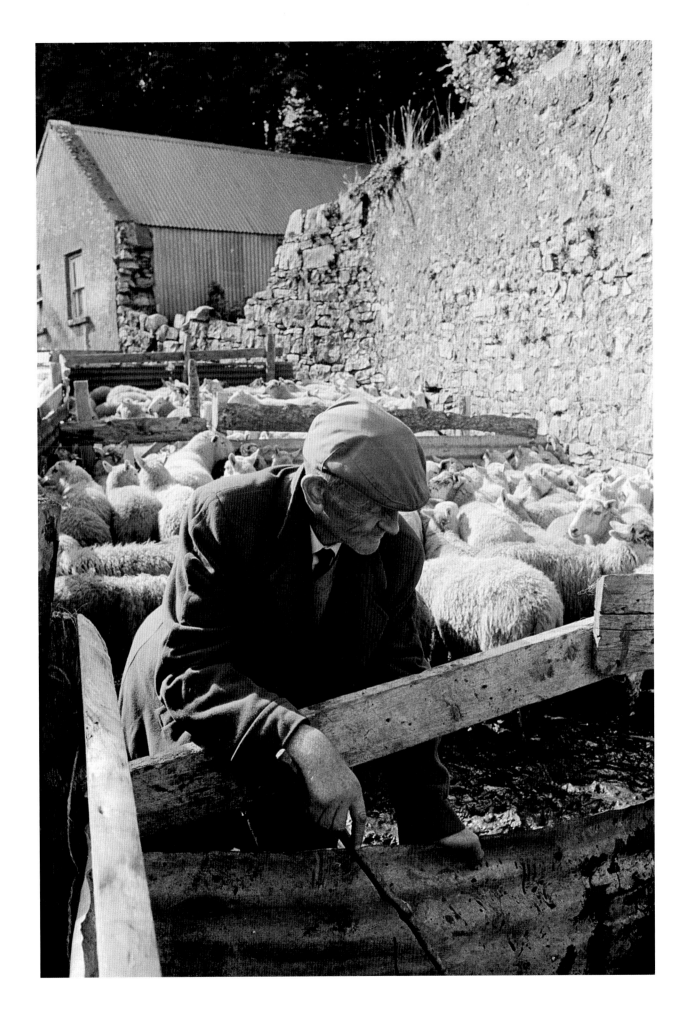

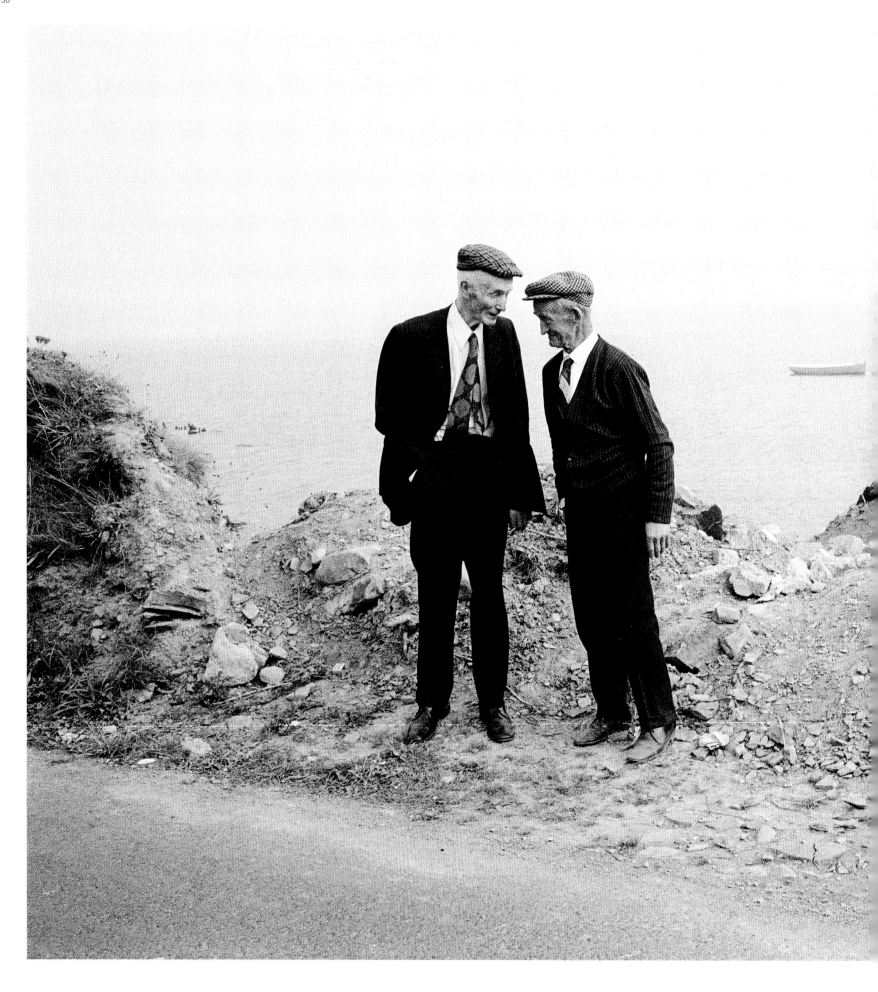

TARBERT County Kerry *overleaf:* LAHINCH County Clare

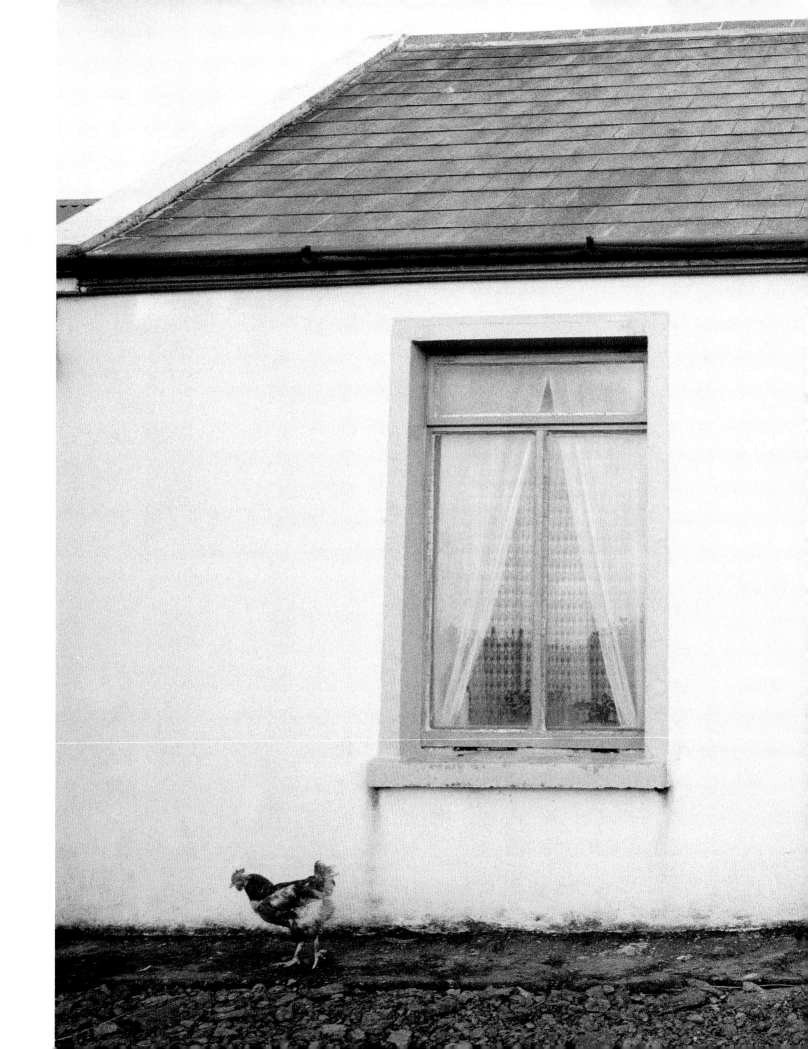

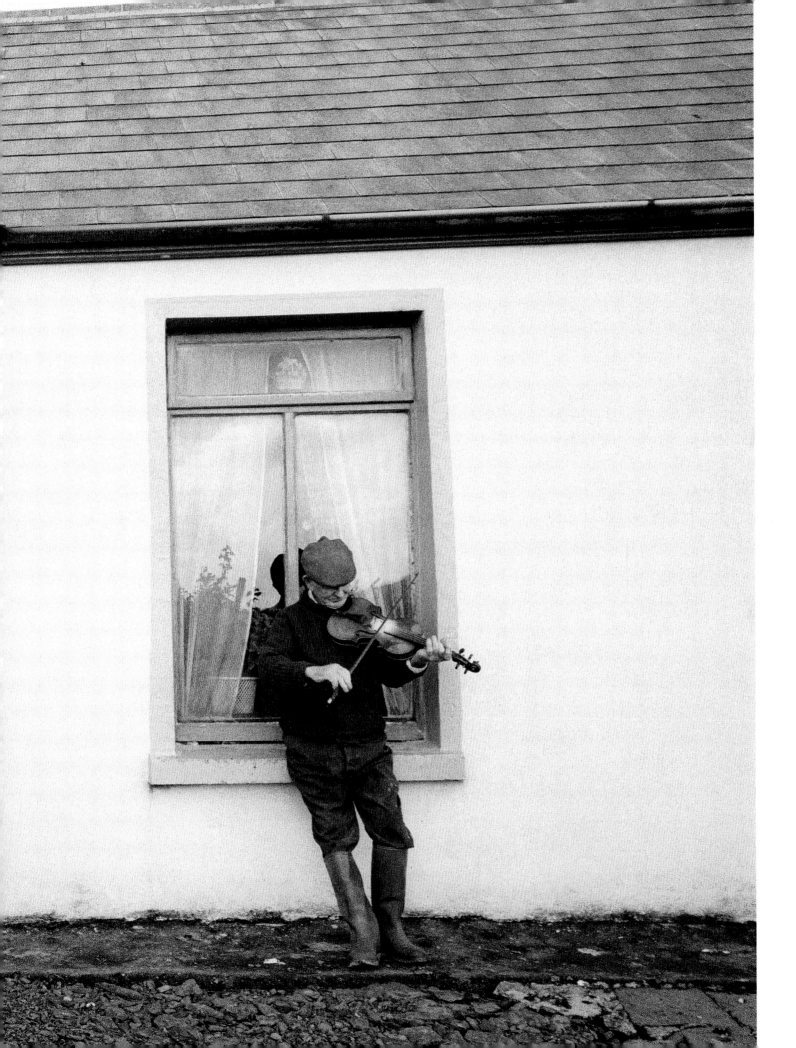

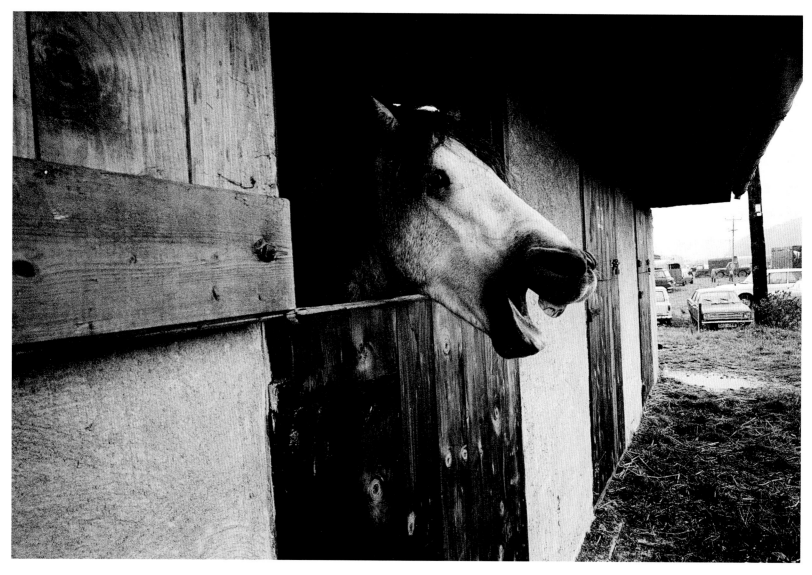

CLIFDEN, CONNEMARA County Galway

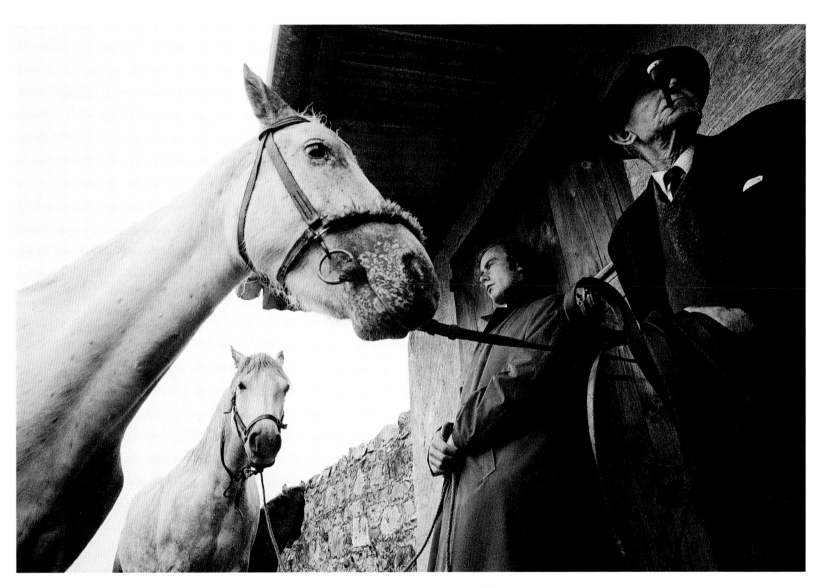

CLIFDEN, CONNEMARA County Galway

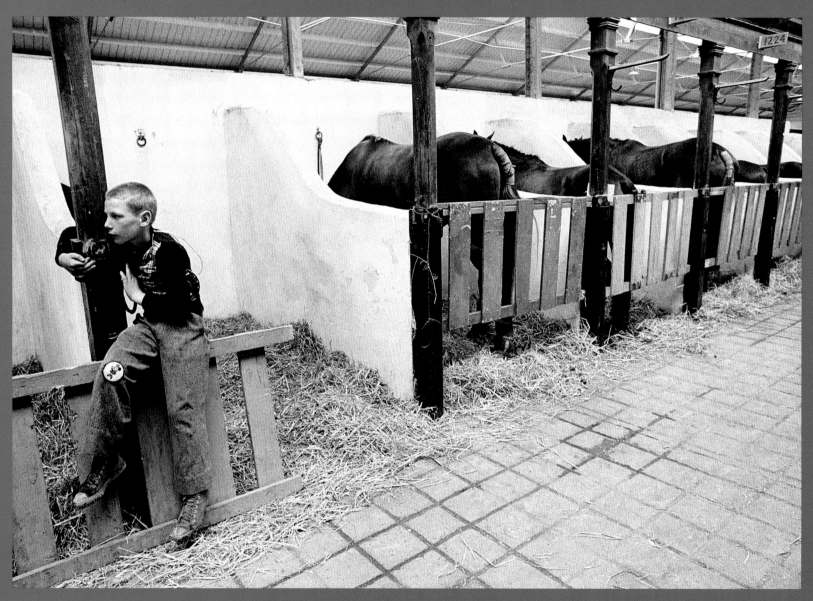

DUBLIN HORSE SHOW

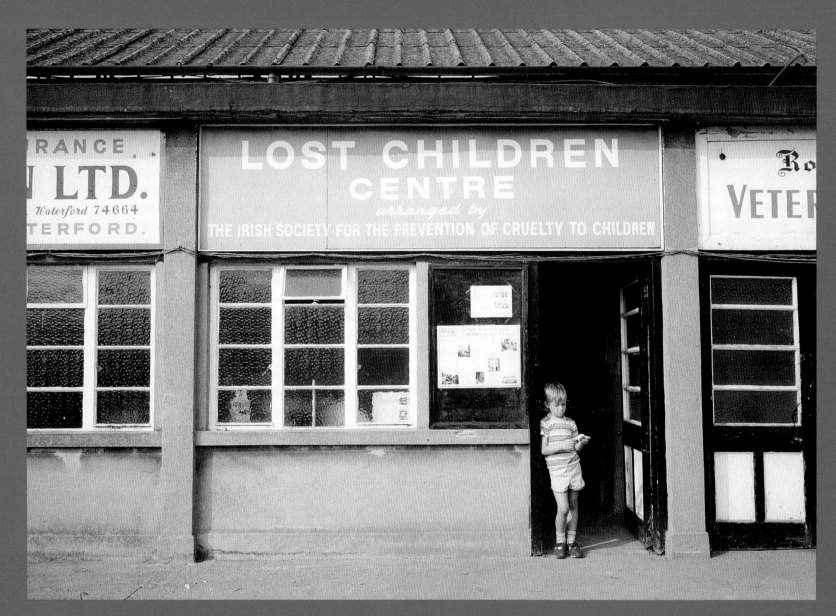

DUBLIN HORSE SHOW

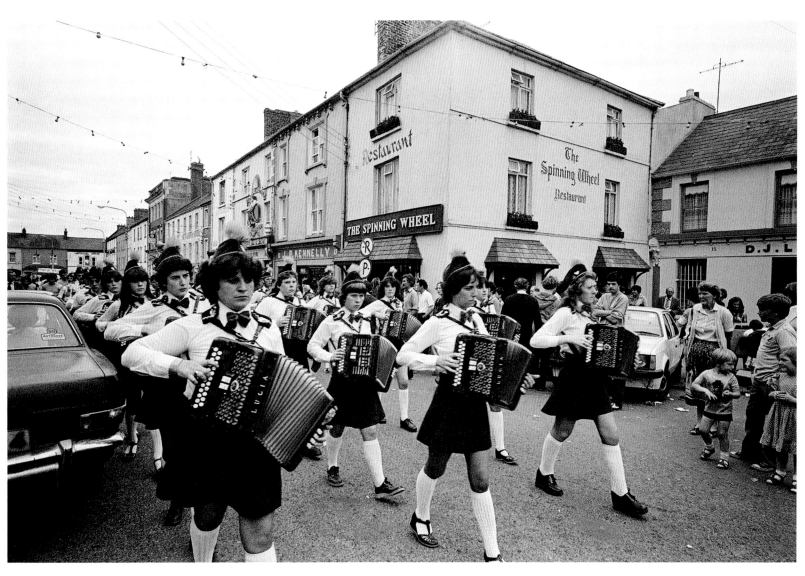

LISTOWEL County Kerry

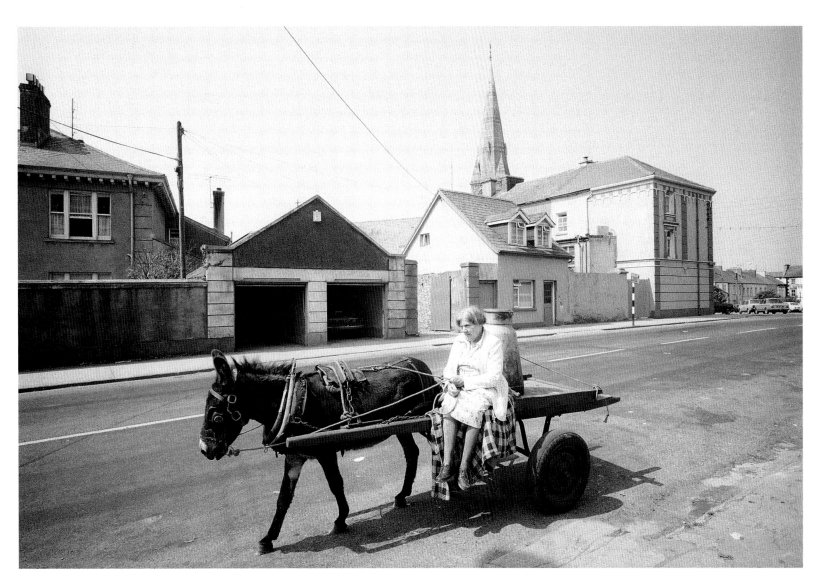

LISTOWEL County Kerry

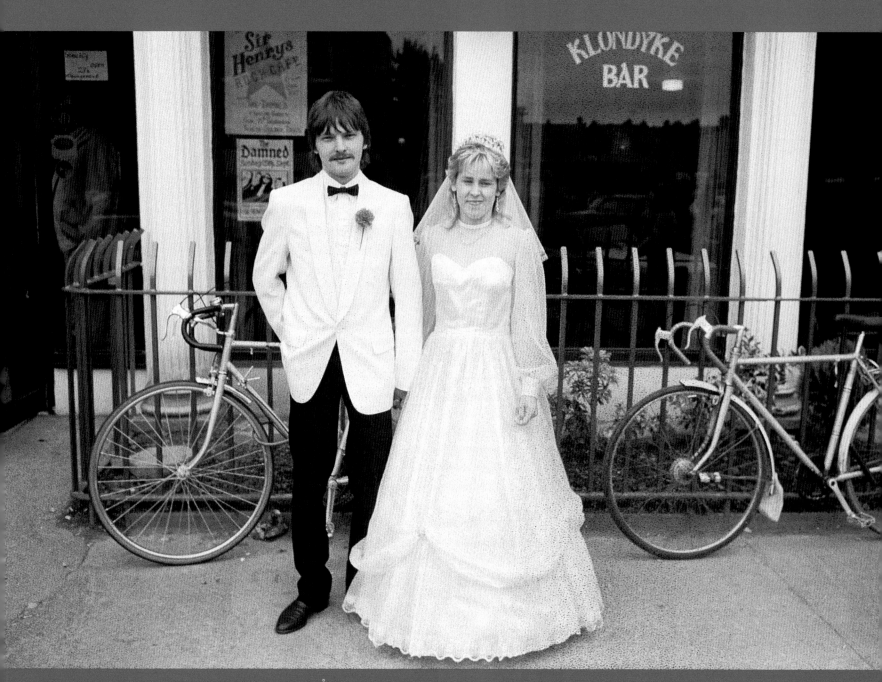

CORK CITY County Cork

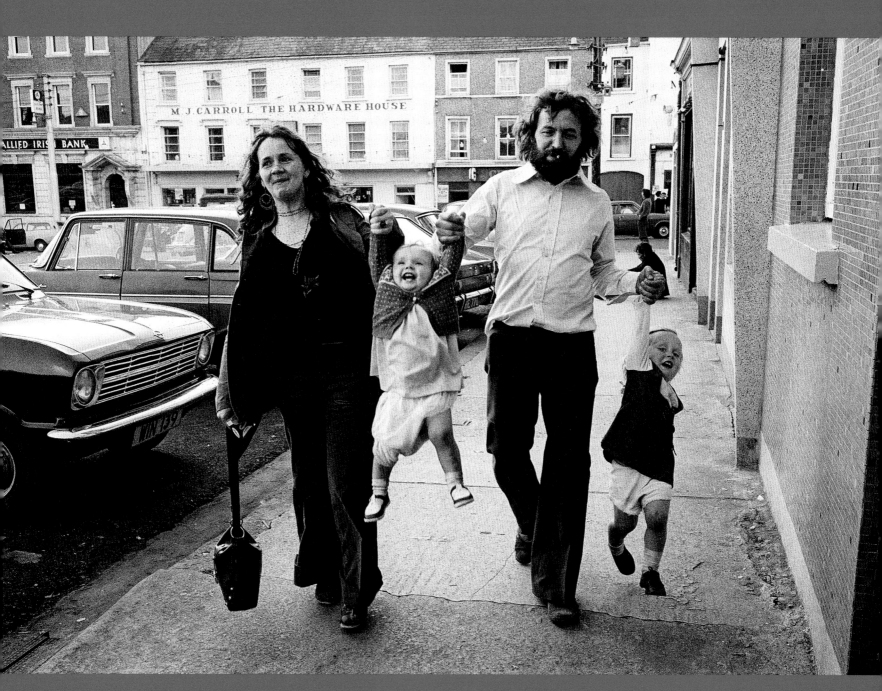

LISTOWEL County Kerry

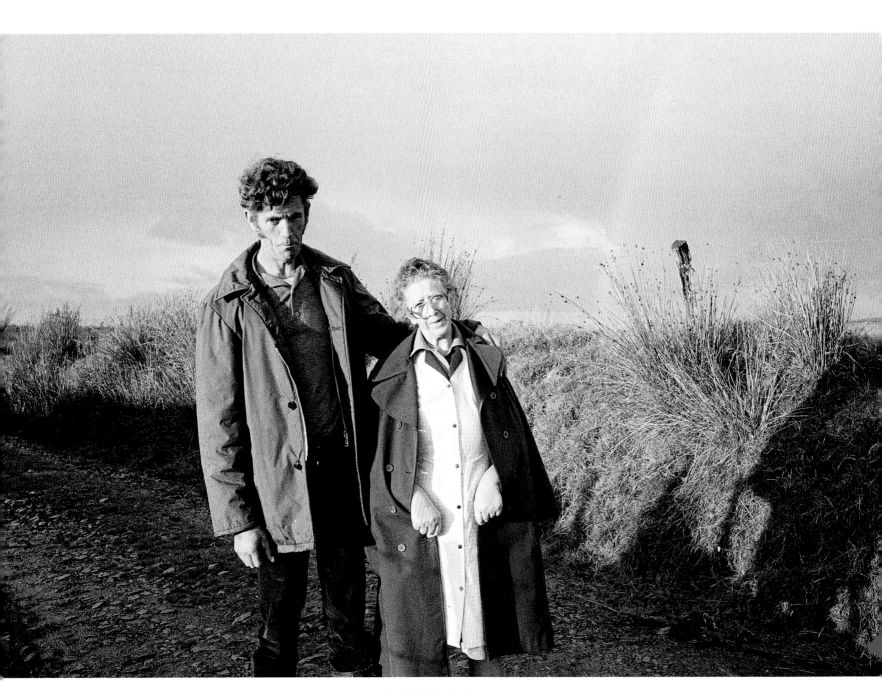

DOWRA County Cavan

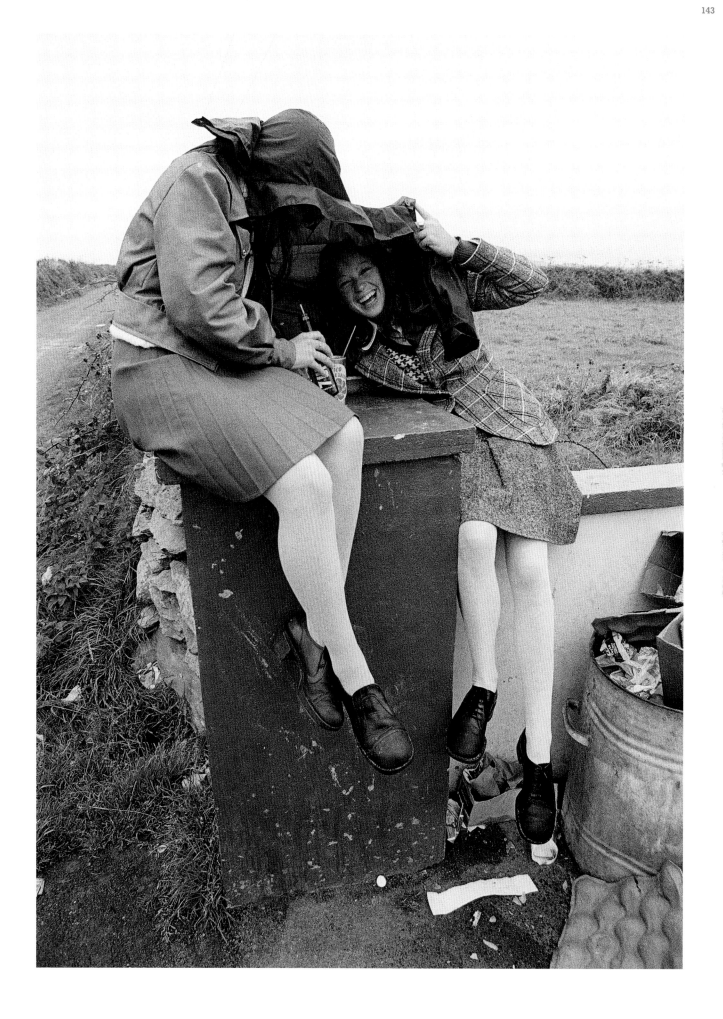

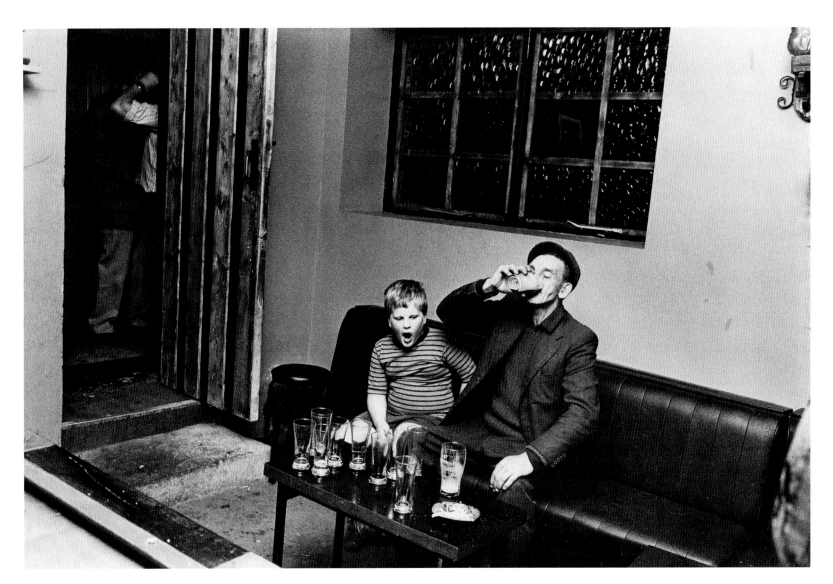

FINUGE County Kerry